ED PIEN

LUMINOUS SHADOWS

Western McIntosh Gallery

black dog
publishing

london uk

05

Building, Dwelling, Thinking

JAMES PATTEN

09

Paper Tigers & Surround Scrolls

CATHERINE DE ZEGHER

51

Imaginary Dwelling

65

Spectral Drawings

97

The Spectral Drawings

ANGELA KINGSTON

106

List of works

108

Contributors & Acknowledgements

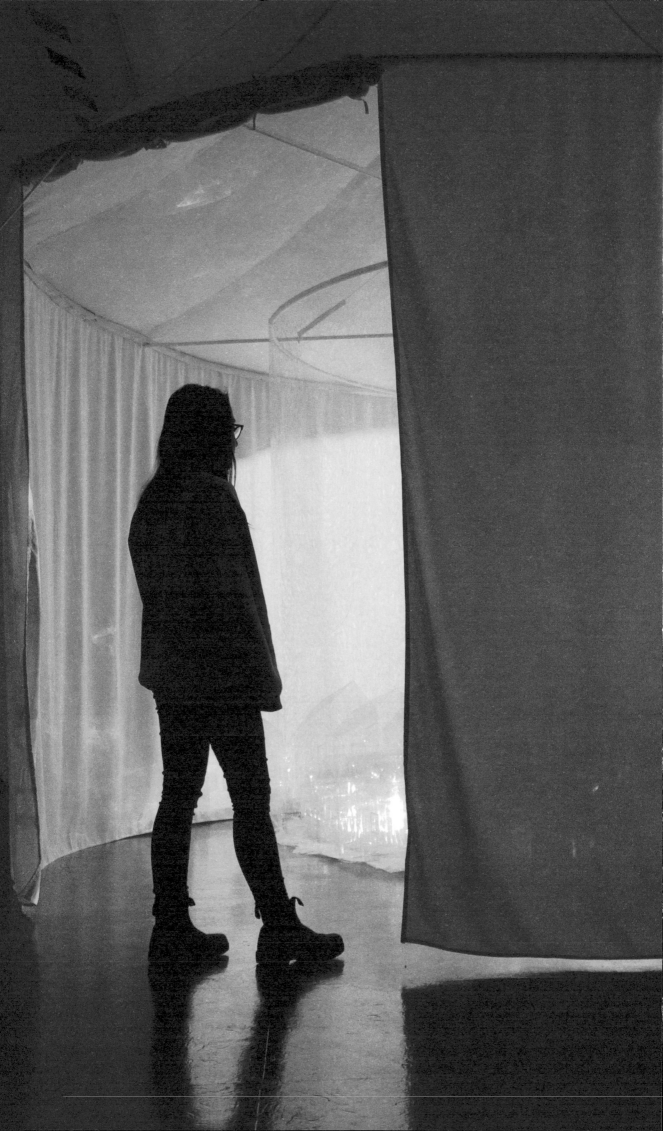

JAMES PATTEN

BUILDING, DWELLING, THINKING

Ed Pien: Luminous Shadows presents two installations by the Toronto-based artist: *Imaginary Dwelling* and *Spectral Drawings*. Created for the 2013 Moscow Biennale and inspired in part by the Inuit artist Shuvinai Ashoona, *Imaginary Dwelling* consists of a townscape made of transparent houses inside a large tent animated with video images, suspended mirrors and the shadows of exhibition visitors. The installation deals with home, a complex topic at the best of times. When it encompasses the plight of refugees, cultural displacement, and intangible feelings of belonging and estrangement, as it does in Pien's work, it becomes a profoundly nuanced subject.

With its layers of transparent and translucent materials, *Imaginary Dwelling* reflects in its very construction the transitory nature of home, which often seems more permanent and fixed than it actually is. The installation looms large in the gallery, as notions of home tend to do in memory and desire. There are dwellings within dwellings here, each with its own story. In a remarkable feat of gentle orchestration, Pien's deftly attuned engagements with other people build a provisional, discursive community of the displaced: from the Inuit who continue to suffer from forced relocation during the mid-twentieth century to the current refugee crisis that encompasses a vast swathe of the globe.

With remarkable consideration and sensitivity Pien collaborates with individuals from the communities he alludes to in the creation of his work. For a workshop he conducted in London, England in 2008, he invited refugees and asylum seekers to make models out of clear Mylar of the homes they had left behind, or homes they hoped to occupy in the future. These models inspired the foldable Mylar house found in *Imaginary*

Imaginary Dwelling,
2012–2015, clear mylar,
fabric, sound and video
5.18 x 3.96 m

Dwelling. With Sisyphean determination, two women of different generations continually shuffle these model houses in videos that emanate from the circular tent, which is emblematic of the simplest and most universal type of shelter. Gallery visitors, like so many travellers, contribute their transient images as they pass through its folds and recesses.

If *Imaginary Dwelling* speaks to the vicissitudes and vulnerabilities of our physical and social location, *Spectral Drawings,* in contrast, evokes the interiority of the mind and our dreams as another home we occupy. It depicts ghostly figures rendered in white emerging from a background consisting of sheets of black paper pinned to black walls. The figures seem to float in what Catherine de Zegher describes in her essay "a haunted world of hybridized creatures". The overall effect is that of an amorphous universe, a black-holed vortex, in which the past and those who inhabit it (including ourselves), coalesce and disperse, collide and repel, according to the vagaries of time. Pien thus traces the reflection of our subjective, meditative relationship to time and space. This is the poetic realm in which, according to Martin Heidegger's famous interpretation of a Hölderin poem, we dwell in relation to an unmeasurable sky, beyond the grasp of rational thought or scientific reason. He asks: "But through what do we attain to a dwelling place? Through building. Poetic creation, which lets us dwell, is a kind of building."[1]

Heidegger wrote his landmark essays, "Poetically Man Dwells" and "Building, Dwelling, Thinking" in 1951 when much of Europe was devastated by the Second World War, resulting in an acute housing shortage and a refugee situation even worse than what we see today. It was a catastrophe of physical suffering and material need that precipitated an existential crisis arising from disillusionment with Modernism, which had failed utterly in its promise of rational, material progress. Heidegger was struggling to square the two aspects of dwelling–physical and metaphysical–amidst Europe's ruins and the aftermath of war.

If *Imaginary Dwelling* demonstrates Pien's concern with dwelling in its physical sense of a place, a homeland or a house, with *Spectral Drawings* he evokes our poetic relationship to a world in flux, never capable of being grasped in its totality: an immersive, limitless environment in which we dwell poetically. As an antidote to Modernism's continued failure, the imaginary for Pien, as with Heidegger, arises from a reflective position in relation to an unknowable universe.[2]

Pien's work is remarkable in that it is borne of both urgency and duration. He exploits the frenetic indecisiveness of drawing, its tentative, pulsating demonstration of quivering touch and gesture. This is particularly evident in the *Spectral Drawings* in which the velocity of his chimerical figures create retinal traces as they move through space leaving behind a sort of stop-motion residue of star dust. In contrast, other aspects of his work, for example, his cutting and removal of materials such as paper or, in the case of *Imaginary Dwelling,* clear plastic sheets, demonstrate patience and an almost meditative, self-effacing effort. He meticulously creates flowing traceries and silhouettes that, in turn, cast myriad ever-changing shadows. Pien collapses the epic and the infinitesimal traces of our movements, be they historic migrations or personal journeys, physical or emotional, into a reality of time and space that evokes the inconceivable dimensions and duration of being itself.

James Patten
Director and Chief Curator
McIntosh Gallery

1 Heidegger, Martin, *Poetry, Language, Thought,* Albert Hofstadter trans, New York: Harper and Row, 1971, p 215.

2 Foltz, Bruce V, *Inhabiting the Earth: Heidegger, Environmental Ethics and the Metaphysics of Nature,* Englewood, NJ: Humanities Press, 1995, pp 159–163.

Building, Dwelling, Thinking

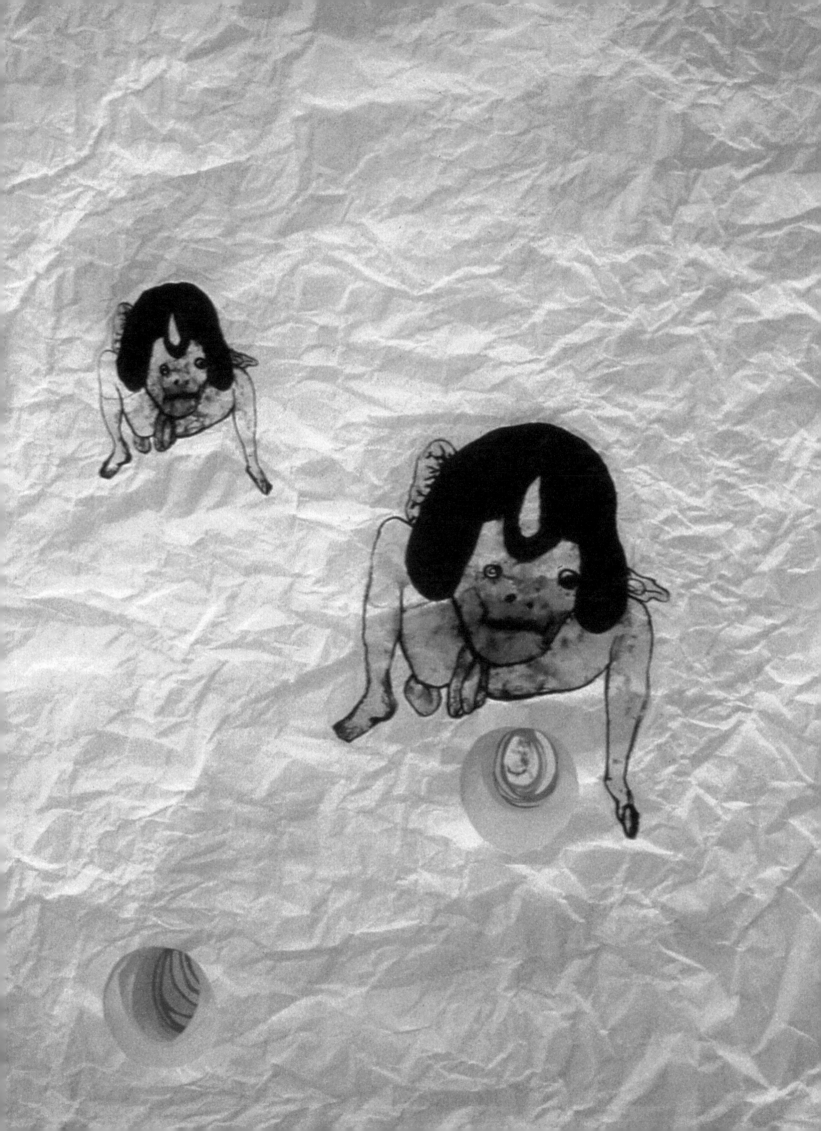

CATHERINE DE ZEGHER

PAPER TIGERS

&

SURROUND SCROLLS

Ed Pien's Unbounded Layering
of Spectral Traces

For Cecil, the treasured black-maned
lion of Zimbabwe

The white man writes everything down in a book so that it will not be forgotten; but our ancestors married animals, learned all their ways, and passed on this knowledge from one generation to another.[1]

As a huge, unrolled scroll hanging vertically in mid-air, this is how I first perceived a work by Ed Pien (b 1958): *For All the Tea in China,* 1999. Made up of large sheets of Chinese calligraphy paper (100 x 245 cm), the cylinder was minimal in appearance with little imagery on the surface. Only when I was closer and peered through small holes in the crumpled paper, did a haunted world of hybrid human and animal creatures uncoil before my eyes. Spectral and unsettling ideograms, as it were! The cylindrical form seemed layered and compounded from manifold sheets—a *mille-feuille,* leaf upon leaf—and its peculiar pictography invited or rather seduced the onlooker to gazing more and more intently, deeper and deeper, voyeuristically....

For All the Tea in China,
1999, ink on paper,
PVC pipes and wood
3 x 2.13 m

Paper Tigers & Surround Scrolls

9

The project was part of one of my first group shows at the Drawing Center in New York (Selections Summer 2000), and since then Pien's works on paper and of paper have never ceased to mesmerize me. Yet, what appeared to be layers of tracings of debauched and profane figures, beckoning us further, our eyes and minds, through the apertures while *mise-en-abyme*—that is, drawing us into all orifices the ghosts, one after another, eagerly exhibited, from mouth to vagina to sphincter—was in fact a cunning trick whereby numerous small drawings were hanging in a row from a stick that went from one hole in the side of the paper cylinder to a central support or to another hole in the opposite side. The crinkled surface allowed for a play of light and shadow as well as for a fine translucency with images mysteriously emerging from the depth.

> Not a red rose or a satin heart.
> I give you an onion.
> It is a moon wrapped in brown paper.
> It promises light
> like the careful undressing of love.[2]

For many years after, the art of layering with paper and pen became Pien's: with layers either concentric like the skins of an onion or spiralling as the interior of a snail, or cyclically cylindrical and labyrinthine.... The ancient Egyptians worshipped the onion, believing its spherical shape and concentric rings symbolized eternal life, perhaps as here, of souls, spectres and spirits. Indeed, much of Pien's work is inspired by Chinese ghost stories and images from *The Classic of Mountains and Seas* (also known as *Shan-hai Ching*). The vast and mysterious ground of Chinese fancy and fantasy, which transpires through the work, derives from his childhood in Taiwan and later journeys of research—ghost stories like *The Soul of the Great Bell, The Story of Ming-Y, The Tradition of the Tea-Plant* and *The Tale of the Porcelain-God....*[3] According to the artist, those stories may have been influenced by the moral teachings of Confucius mixed with Daoist beliefs. He describes a particularly woeful tale about strange and fantastic water ghosts: "Moreover, water ghosts represent the souls of people who once drowned. Trapped in their watery grave, their souls can only be set free when they pull other people into the water and drown them."[4] Pien tells me that a lot of Taiwanese are afraid of rivers or seas

The Promise of Solitude
(details), 2005
ink, Shoji paper, thread,
wood, PVC pipes
3.96 x 6.1 x 6.1 m

Ed Pien: Luminous Shadows

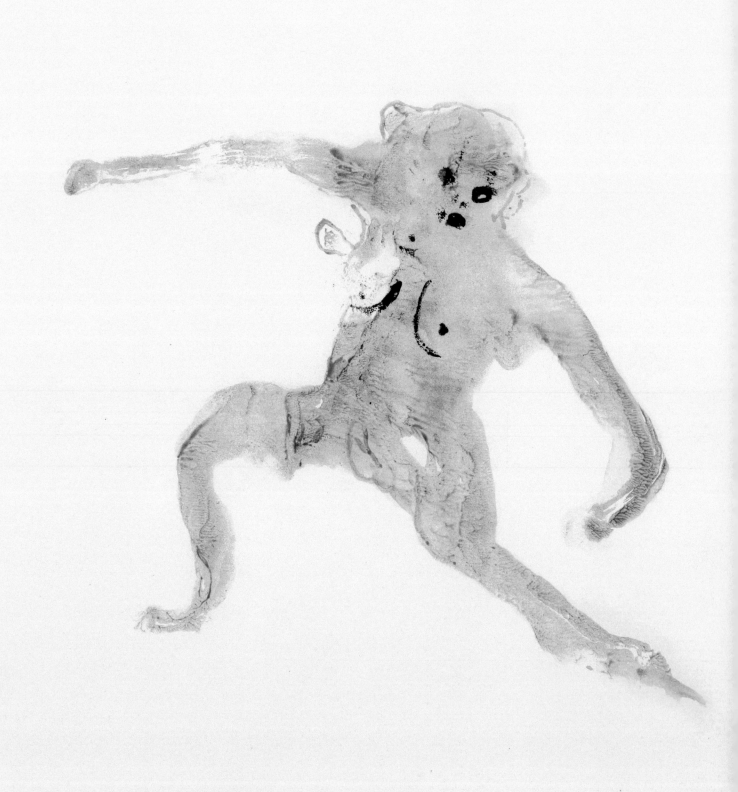

because of these ancient stories, in effect, "because of these culturally engendered anxieties and value systems. As a consequence many fear the water and don't learn to swim, and when falling in the water they often drown, because the water ghosts pulled them in. It thus becomes a self-fulfilling prophecy."[5] In this, Pien appears fascinated by the construction of fear, of vulnerability too, and its consequences. His paper work takes up and takes on these paper tigers: it aims to deconstruct induced manipulation and challenge ominous disquiet in our daily environment to allow critical analysis of extraordinary events.

In his installations, the artist combines Asian and Western histories and mythologies, bringing them to bear on present-day realities. An ancient survey of the world, *The Classic of Mountains and Seas* is sometimes said to be a parallel in Chinese literature to Medieval Latin bestiaries in Europe: books of sacred landscapes filled with marvels and monsters, corpse deities, mysterious foreigners, fabulous creatures and man-eating hybrid animals.[6] It tells of an age-old reciprocity between humans and the animate earth, of the relation between traditional magic and the natural world—all familiar to the shaman. And in retrospect, it tells of our estrangement from a direct sensuous reality and a multi-voiced world.... Largely because of the mythic geographical content of the texts, however, *The Classic of Mountains and Seas* does not provide information as historical documents might of a place and its geography but rather speaks of archaic societies, their mythologies, cultures and ceremonies, like the snake-cult and others performed by male and female shamans. Furthermore, in an ancient time, head shamans often became kings or queens because of their mastery of magic powers and practices, mediating between the human community and the larger community of beings upon which people depended for their nourishment and sustenance—from the land with its diverse plants and myriad animals to the winds and waters, forests and mountains. Sometimes, too, the shamans could hold together the lands because of a common belief in the power of their sorcery. A world order was maintained not by political negotiation but by the strength of belief in magical powers and mysterious energies, and the fear of the possible consequences of transgressing authority beyond human agency.

In a certain way, Pien's complex and multilayered drawings come to encompass traces of an animist world view, much like the drawings of the Anishnaabe artist Norval Morrisseau/Copper Thunderbird. Born

Paper Tigers & Surround Scrolls

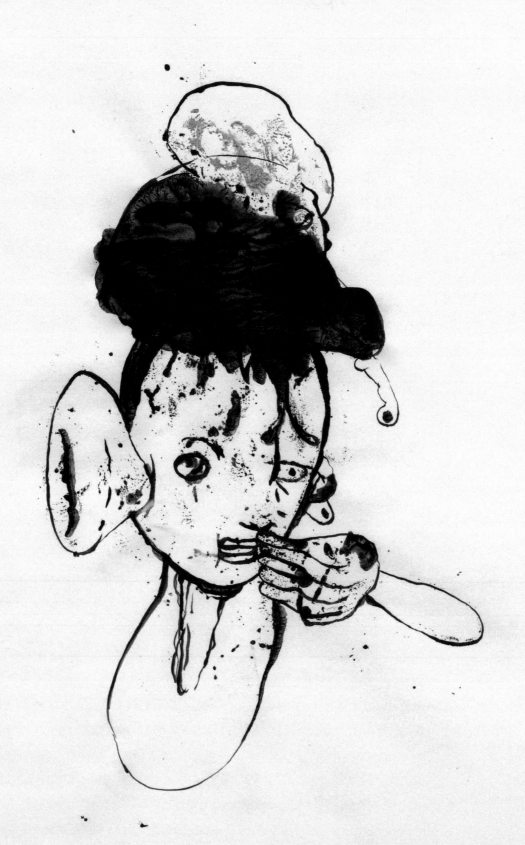

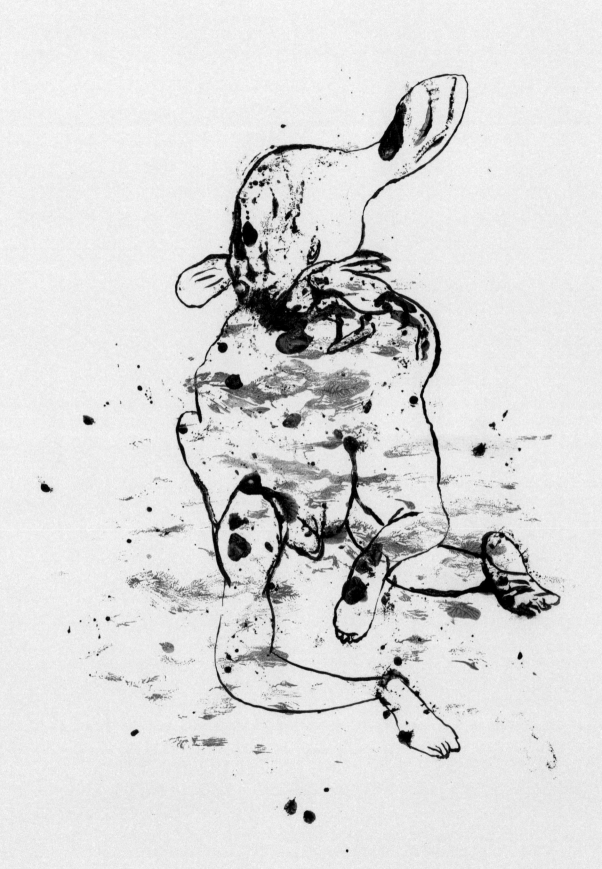

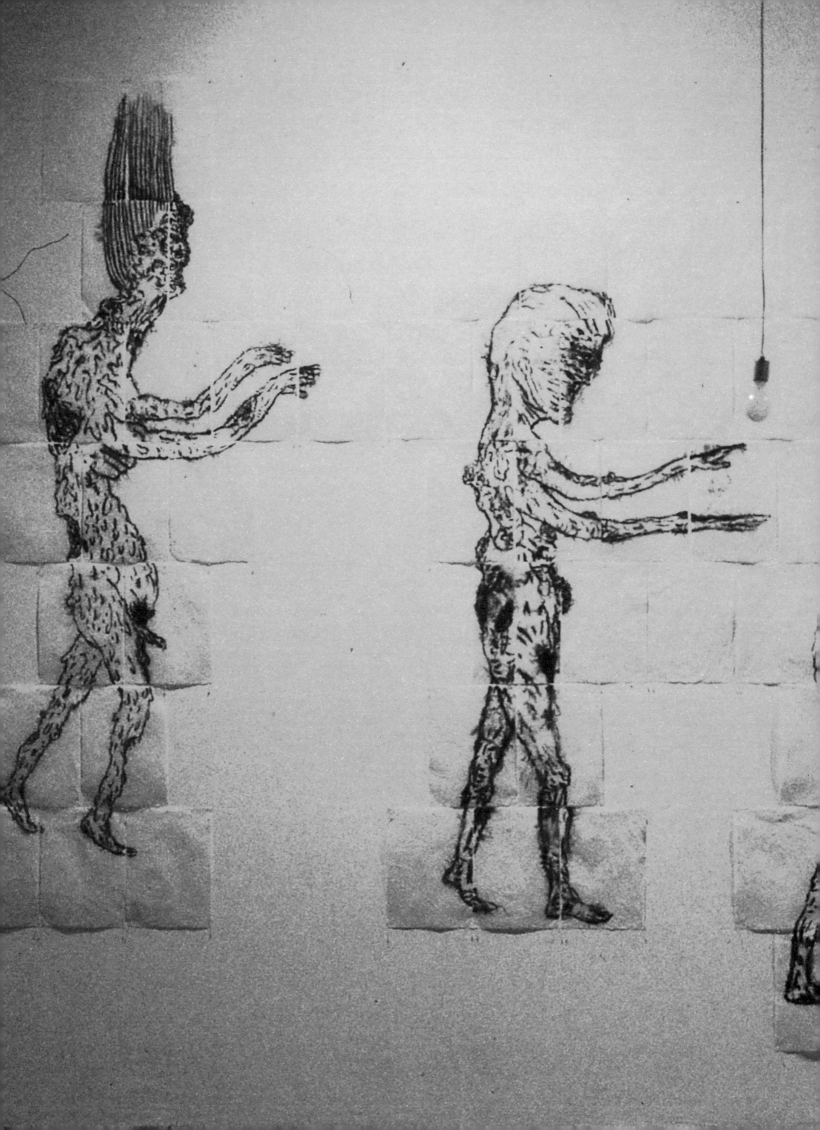

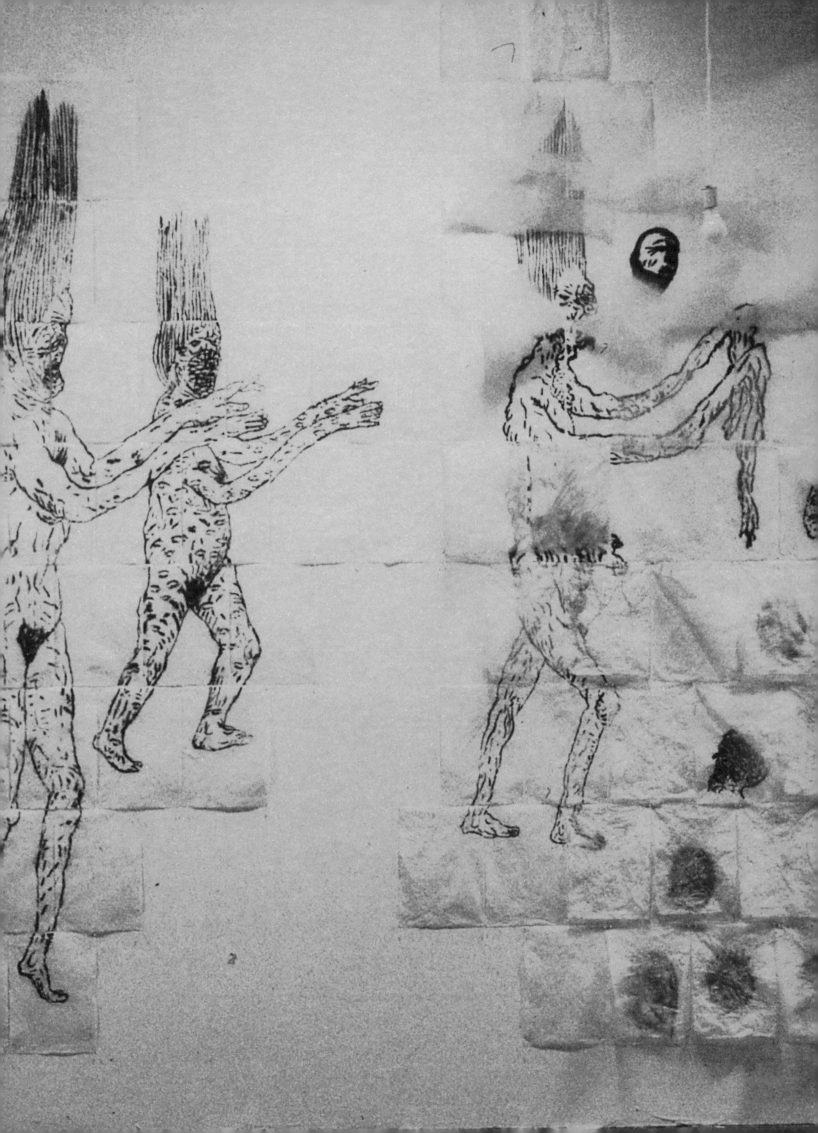

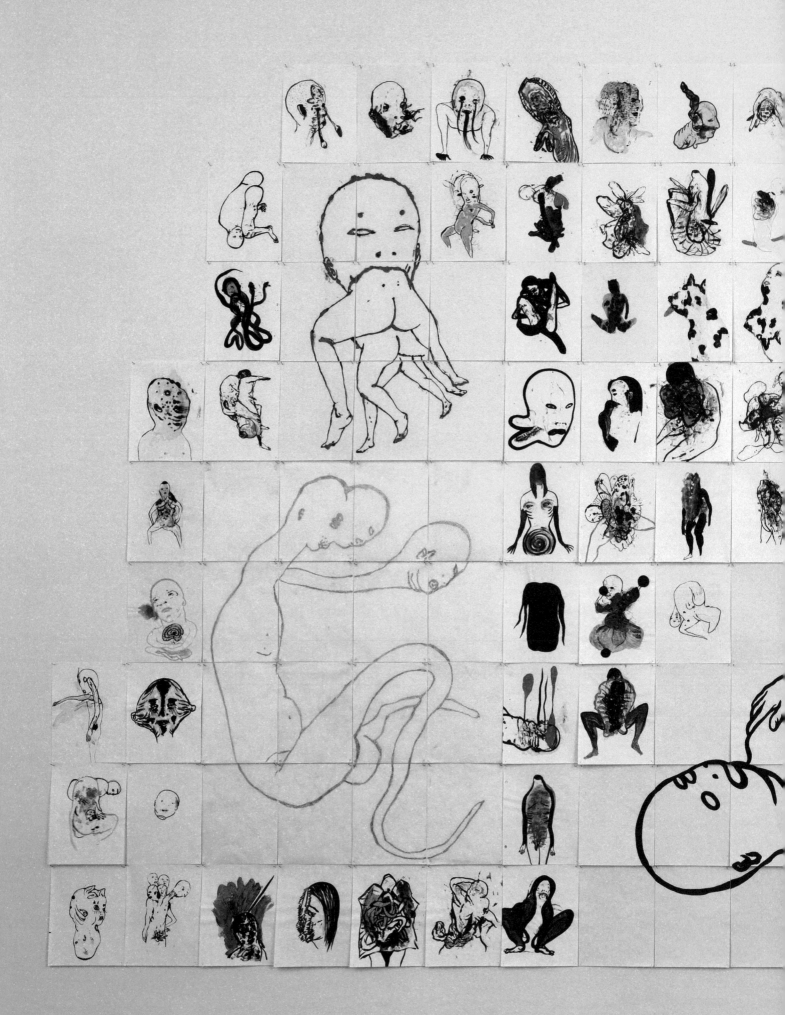

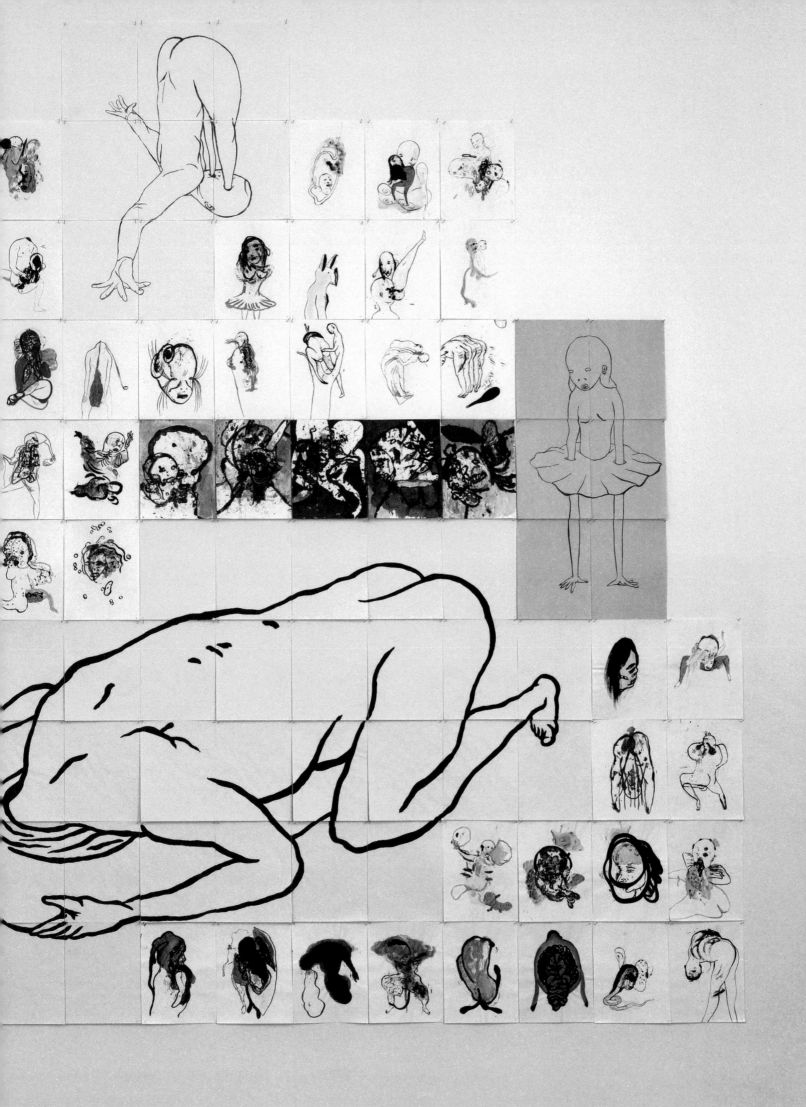

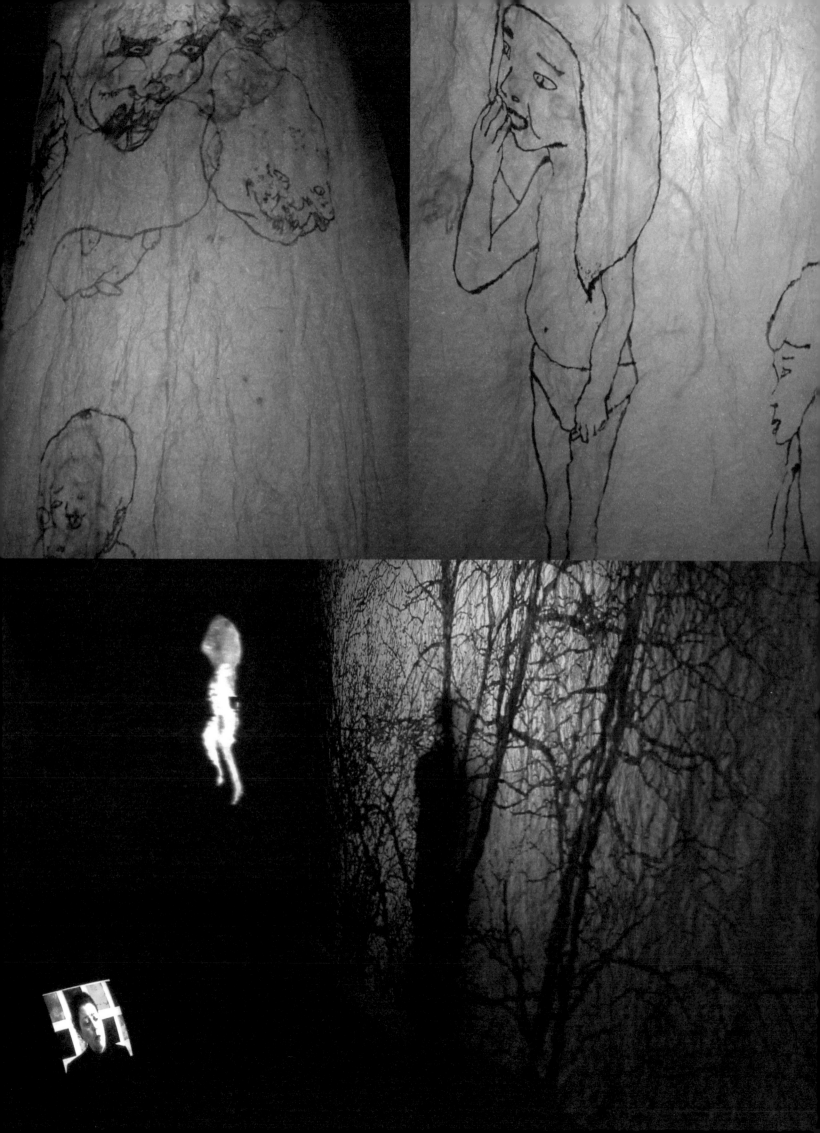

pp 16–17
Ghosts, 1998
ink on Japanese silk
paper and tracing
paper, light, motion
sensor and ceiling fan
variable dimensions

pp 18–19
Drawing on Hell,
Paris, 1999–2004
ink and Flashe on paper
2.79 x 4.12 m

In a Realm of Others,
2001, ink, glassine, PVC
pipes, sound, video
projection, TV monitor
12.3 x 5.54 x 4 m

in 1932 on the Sand Point Reserve, on Lake Nipigon near Thunder Bay in northwestern Ontario, Morrisseau was encouraged by his grandfather Moses "Potan" Nanakonagos, a shaman, to transmit through art the legacy of Anishnaabe values, oral traditions and beliefs before their potential vanishing in a community at the edge of Canadian life. In an almost imperceptible manner in his art, humans transform into animals, while fish, bears, buffalo, birds, turtles and snakes take on anthropomorphic features—much as a merman is half man, half fish. More than depicting the complex network of his graphite, lines 'enact' movement and reverberation, interweaving all of the pictorial elements and filling the image-plane of the paper. Whether connecting the figures or simply emanating from them, these lines seem to resonate with energy, particularly when they trace power being transmitted through the senses. Often a wavy line, extending from the mouth through the throat to a circular or ovoid form in the chest, flows through the body to leave at the anus. Attached to the heart this seemingly vibrating line represents the life force itself and, by extension, records the survival of a threatened culture by giving it contemporary relevance. Morrisseau's work brought the interconnected spoken and graphic aesthetic expressions of a tradition into modern visual art.[7]

Having migrated with his family to Canada at the age of 11, and now living and working in Toronto, Pien became increasingly invested in the history, housing and art history of the First Nations people, in particular of the Inuit. Yet, he also often returned to his native country for extensive research. Pien's 1997 trip to Taiwan resulted in the creation of hundreds of drawings and three installations: *Ghosts*, 1998; *Deep Waters*, 2001; and *In a Realm of Others*, 2003. Relying on key festivals, rituals and ceremonies, his exploration comprised field studies and in-depth interviews as well as readings on Taiwanese cultures and systems of belief. If on the whole his early drawings are small and representational, alluding to aspects of fairy tales, the more recent ones are sizeable and fairly nonfigurative. *Tracing Night*, 2004, was inspired by childhood wonder and fear of the night. In preparation for this work, he studied the Tang Dynasty's animal allegories, astronomy and star lore, as well as legends and the visual arts of the Inuit.

Tracing Night incorporates sound and video to explore the concept of transformation as a possible means to challenge and negotiate potentially threatening situations. *The Promise of Solitude*, 2006, contemplates the

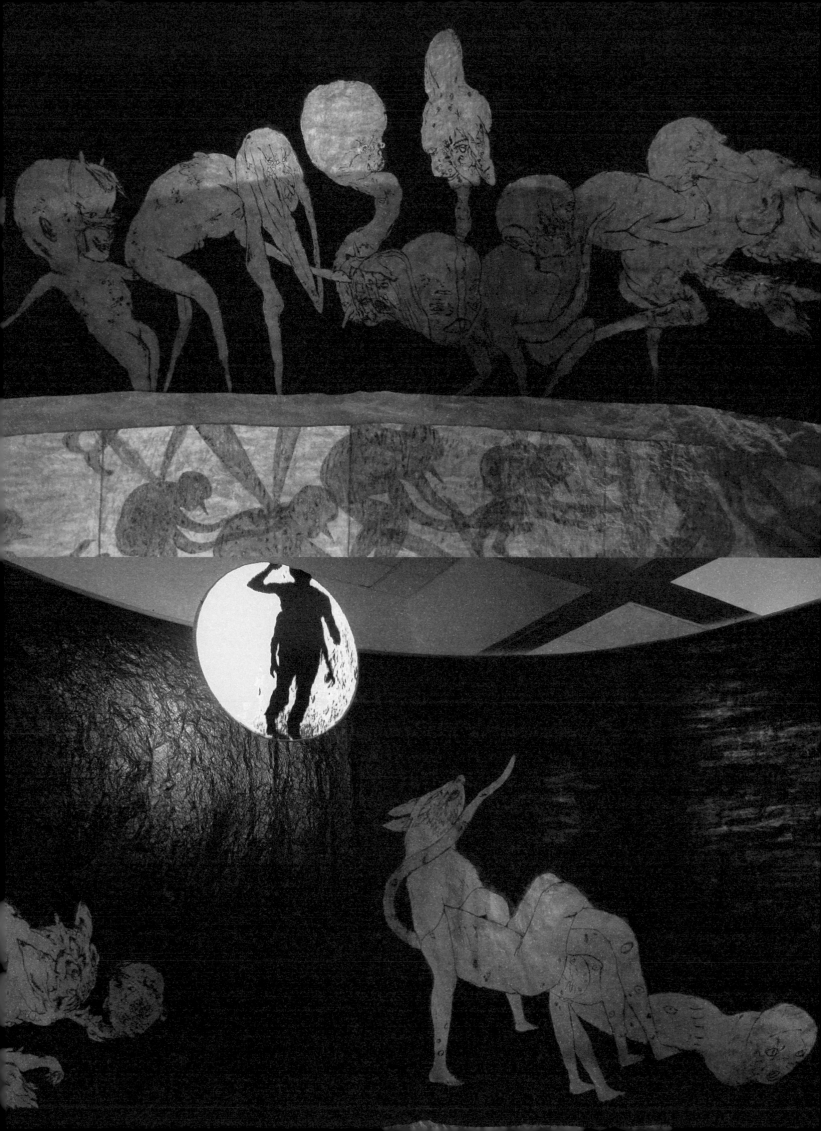

idea of a journey—both, within and without—to unknown territories and the potential for change that such journeys promise and offer. *In Haven, 2007*, concepts of privileged home, sanctuary and belonging eventually lead to Pien's reflection on their opposites: without a home(land), homelessness, migration and the plight of refugees. *Une nuit de lunes, 2008*, explores the sense of the grotesque, the formation of subjectivity and the notion of the Other. The conceptual research for *Memento, 2009*—on the plight of illegal immigrants—was initiated during a residency at the Chinese Arts Centre in Manchester, England. Thematically, *Memento* evolves around the relation of visibility and invisibility, the sense of presence and ephemerality, the many meanings and implications of the word "ghost", as well as tracing complex and conflicting emotional states, including longing, uncertainty and nostalgia.

On the level of subject and social engagement, Pien's work shares ideas and shows parallels with the scrolls of the Chinese artist Yun Fei Ji (b 1963), whose work not only draws on ghost stories but also takes the urban drift as a topic in *The Three Gorges Dam, 2010*, commenting on the infamous displacement of millions of Chinese people who were forced into rural-urban migration. Often the "rural flight" is caused by unpredictable environmental disasters of drought or flooding, but here it was planned as part of a highly organized yet increasingly disastrous policy with the goal to increase the country's energy levels and with it capital gains. Sadly, according to Yun Fei Ji, the relocation of these villagers, who used to live close to the earth and the water, often turns them from self-sufficient farmers into destitute city dwellers. Inspired by the century-old *Book of Changes*, the artist, however, continues to advocate the preservation it stipulates of "the harmony between all things on earth to have a long period of peace and stability".

STRATUM & SPECTRUM

Through his work Pien studies the convergence of history and mythology across a wide spectrum of local cultures, and as a stratum itself with many layers of meaning, in an attempt to make art in a globalized world more engaging and critical. Again, Pien's art is in many ways one of layering, and this is most apparent in the primary gestural act in the distinctive

Ed Pien: Luminous Shadows

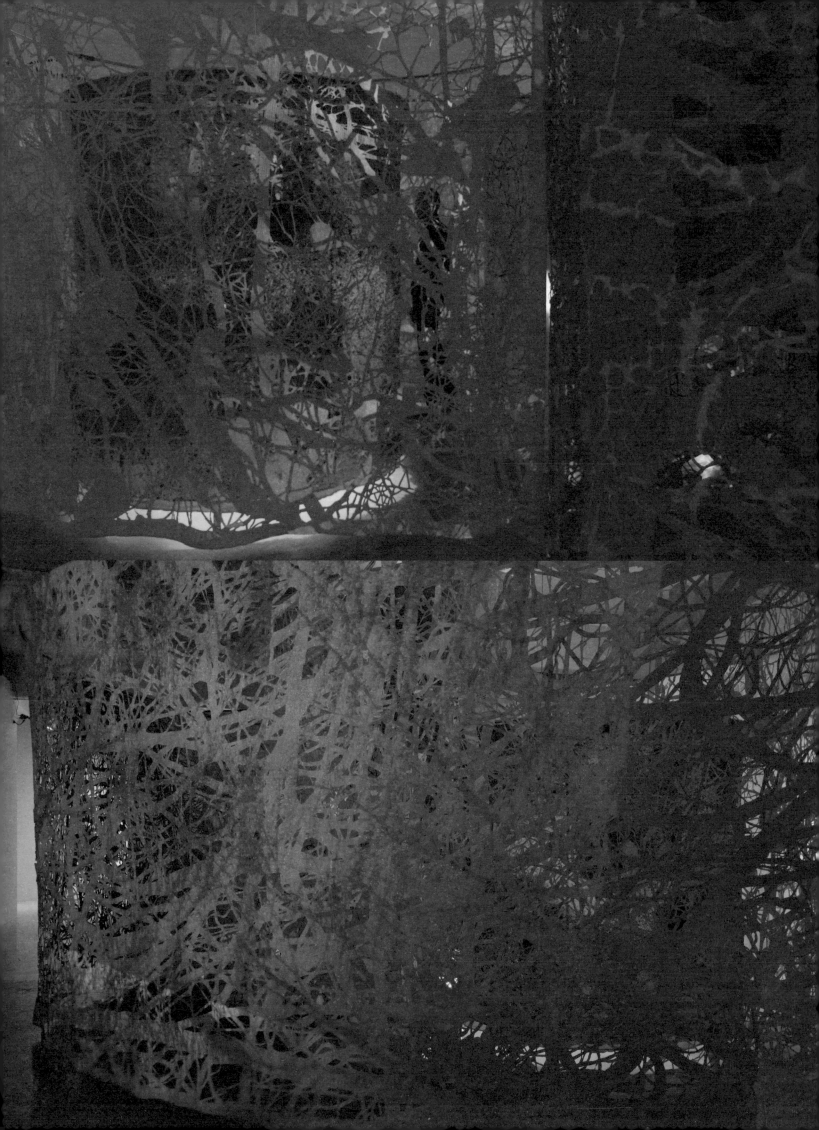

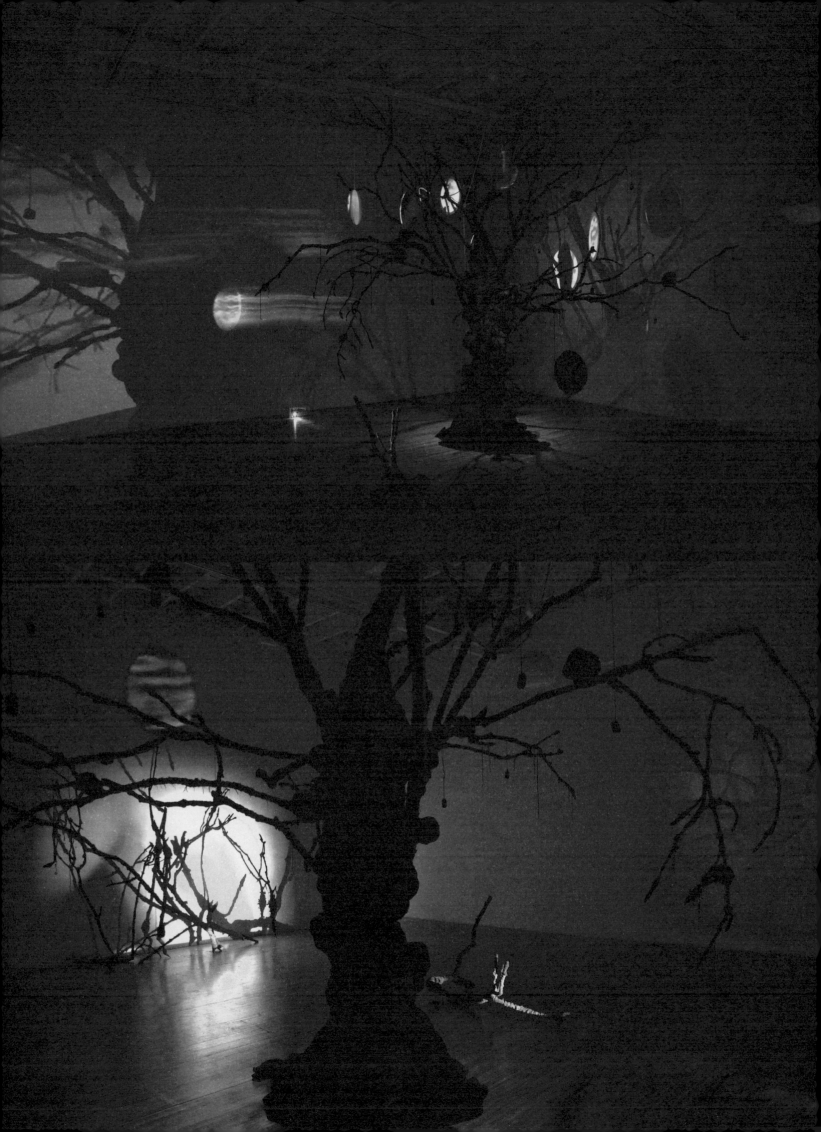

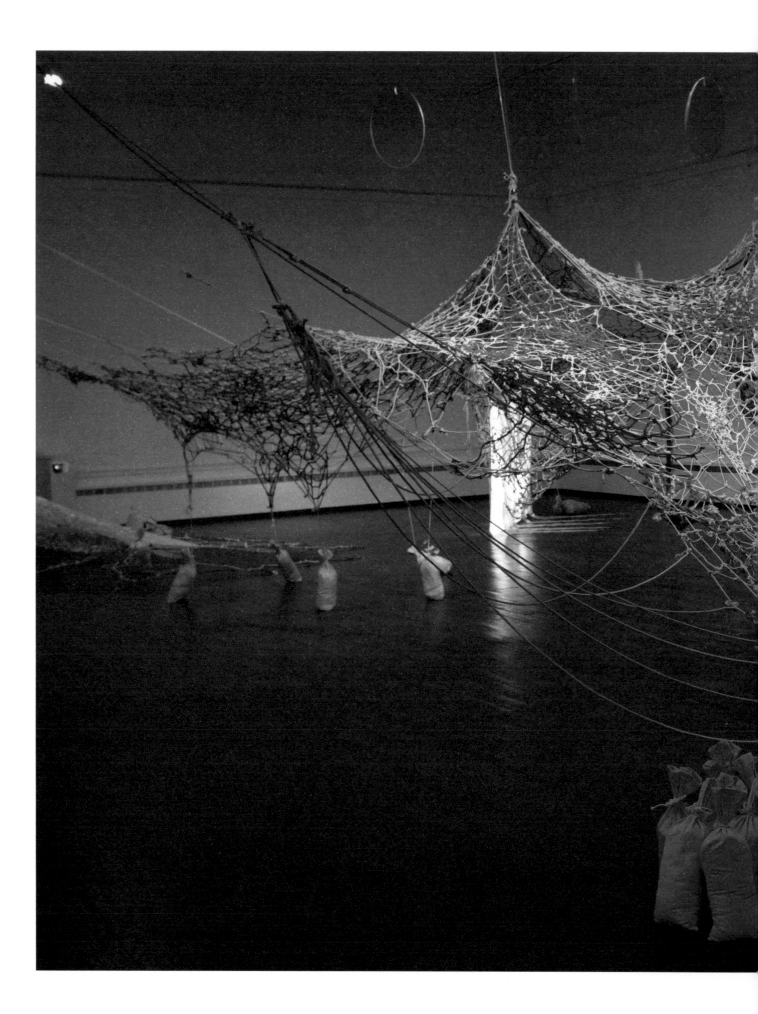

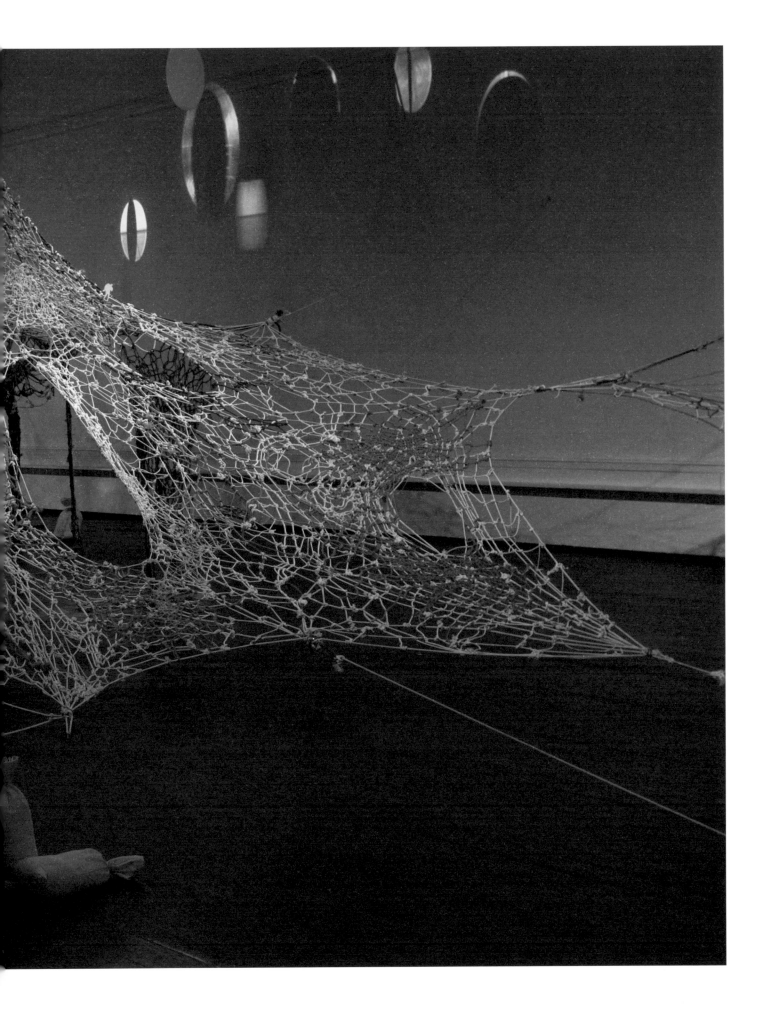

drawing method he developed over the years. In this method, traces of traces of traces ultimately shape the works. Pien says:

> The *trace* is an important and integral element invoked in my work. While using ink, Flashe and a sheet of paper to create images, I incorporate a semi-monoprinting technique with another sheet (calling it 'the secondary drawing'), lifting it up and pressing it rapidly and randomly in a three-minute session to soak up the excess ink of the still wet marks and imprint them over and again on the paper being drawn on (calling this 'the main drawing').[8] The back and forth imprinting and transference of wet marks onto these two surfaces— which I consider as a *visual echo*—allows for the speedy and exponential generation of new unexpected smudges as residual traces of my gestures. Then, when I counter and respond to the tangible paper field of chaotic and indecipherable images with intentional marks and lines, images of hybridized and monstrous beings are summoned up.[9]

It is as if Pien is relentlessly trying to capture a fleeting soul or anima—or attention—in a world with little attention to the animate earth. I vividly remember being absorbed by this unusual drawing technique, during a studio visit in Toronto, because to me it appeared to generate a layering in his drawings without the separation into fixed or definite layers. Pien continues:

> When I draw, I mostly use inexpensive acid-free A4 sheets of paper (and sometimes A3). Marks and their traces are now left on both sheets, and with each pressing gesture the emerging traces lessen in intensity and clarity due to the absorption of the paper together with the fading of the ink. Sounds from echoes also dissipate after a succession of returns.[10]

Making just one drawing thus allows Pien to disseminate the marks across many sheets of paper capturing smudges, stains and traces, because he uses numerous secondary sheets to accompany the main drawing: sometimes blank ones, other times sheets with existing traces previously accumulated. A secondary sheet with different traces can also be used to create a new main drawing with further accretion of traces. In effect, at some point, the secondary drawing is used as the main drawing. This

pp 26–27
Memento, 2009
rope, sand bags, mirrors, glassine, Tyvek, sound and video projections
variable dimensions

Grand Thieves (detail), 1999–2010, ink and Flashe on panelled paper
3.48 x 1.97 m

Ed Pien: Luminous Shadows

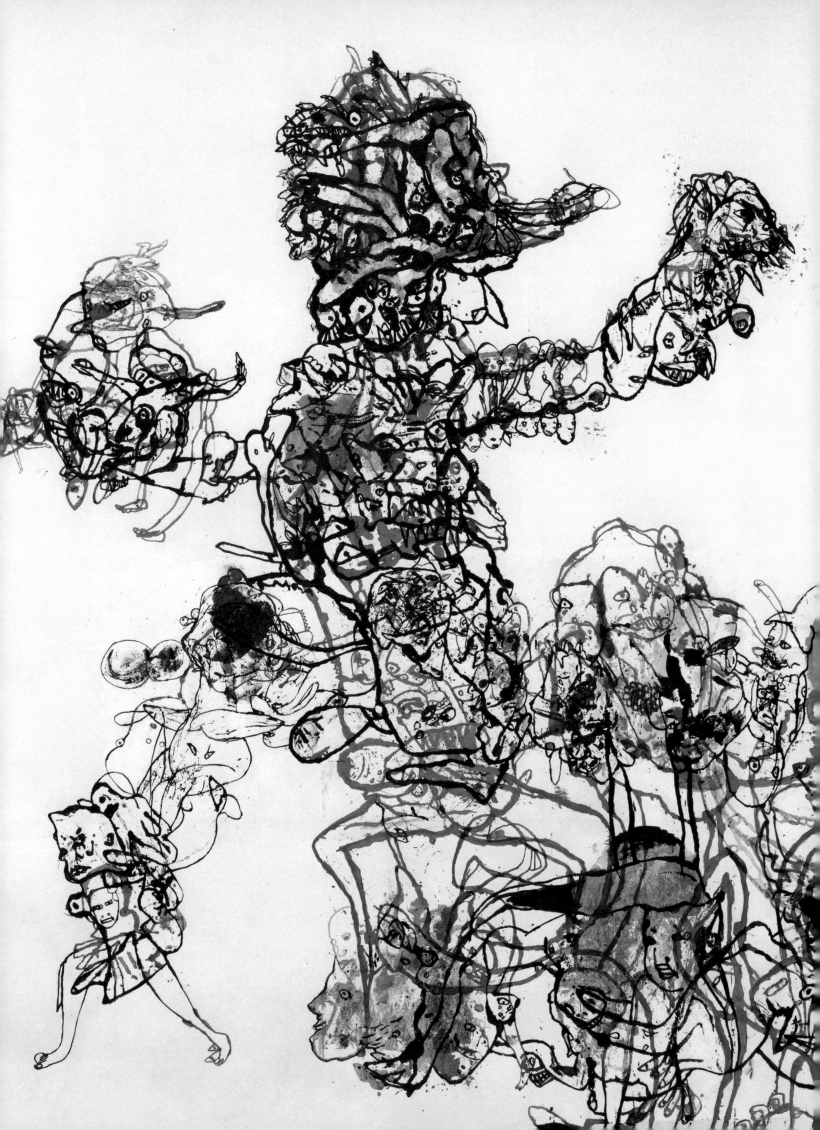

happens before the secondary drawing becomes too dense and too chaotic to work with. In fact, almost all main drawings started out as secondary drawings that had collected a rich layering of traces upon traces upon traces throughout many drawing sessions. Although the emerging images appear ghostly because of this process of transference, a whole narrative with a set of relations unfolds in which significantly all the traces are physically connected. As a result Pien has piled up thousands of these uncompleted images, from which he repeatedly and meticulously selects a few for new three-minute drawing sessions. By drawing and imprinting on each paper in such a short time, velocity and spontaneity are integral to his drawing practice. Over time, another facet of the creative process consists of the precise assortment and collection of almost completed images into a composition for a large drawing (for example, *Grand Thieves* is composed of 116 A4 sheets, each 22 x 28 cm), collaged or taped together from several parts, with a sense of figuration obtained by augmented marks the artist inserts at this stage. As Pien comments:

> In a way, they become a catalyst helping instantaneously to generate a narrative of some sort and to facilitate the conceptual development of my work. I feel as if some of the 'images/characters' want to move to another part of the larger drawing or choose not to participate in the work. For this reason the collaging process takes time, but can be done anywhere at any moment....[11]

Hence, Pien's exponentially growing drawings are never finished, conveying a sense of endlessness and relentlessness while linking history and contemporaneity in their momentum, his story too—past and present. "I just stop working on them (for many reasons)", the artist says,

> Each drawing takes a long time to find some resolution, because I also incorporate drawings that were done ten years ago or more. It is a kind of collaboration with my past self. By allowing older drawings, so-called 'characters', to be included, the work can be much richer in complexity and variety.[12]

While the drawings have open-ended narratives, the density of the imagery in each area of a large drawing releases even more latent narratives. In a

Ad Infinitum (detail), 1999–2010, ink and Flashe on panelled paper 3.92 x 1.97 m

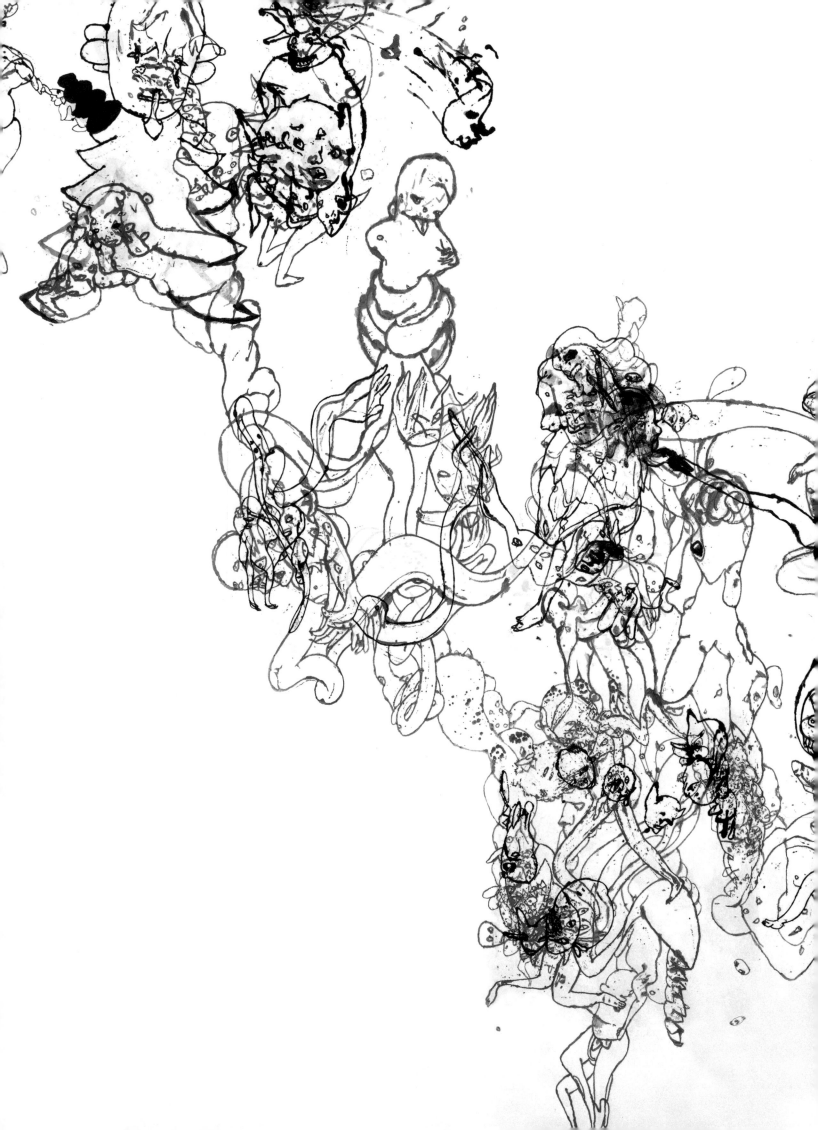

sense, the overall collaged drawing suggests a narrative grander than the sum of the smaller stories. By passing multiple former semi-finished drawings through short sessions, Pien's creative process can be very dynamic, swift, concentrated and intense, lasting sometimes two to three hours, as he takes between 40 and 60 drawings to another level of completion.[13] At this stage, he begins to arrange them, looking for keen and strong dialogues among the different drawings before taping them together. He considers some of his figures as 'characters' that can start a dialogue with another participant or other participants, the work in itself alluding to storytelling.

> Indeed, the addition of an older drawing is done, when I feel a certain 'character' volunteers to participate in the current large drawing. Moreover, I like the fact that I am working collaboratively with my younger self from different time periods of my artist life....[14]

WEN

The word *wen* signifies a conglomeration of marks, the simple symbol in writing. It applies to the veins in stones and wood, to constellations, represented by the strokes connecting the stars, to the tracks of birds and quadrupeds on the ground (Chinese tradition would have it that the observation of these tracks suggested the invention of writing), to tattoos and even, for example, to the designs that decorate the turtle's shell. The term *wen* has designated by extension, literature....[15]

Pien's visual language contains 'characters', smudges and traces like writing. Drawing and writing, like all language, is engendered between the human community and the animate landscape, born of the interplay between the human and the more-than-human world. Our earth is covered with traces and tracings,

> from the sinuous calligraphy of rivers winding across the land, inscribing arroyos and canyons into the parched earth of the desert, to the black slash burned by lighting into the trunk of an old elm.

Ed Pien: Luminous Shadows

The swooping flight of birds is a kind of cursive script written on the wind; it is this script that was studied by the ancient 'augurs', who could read therein the course of the future.... And today you read these printed words as tribal hunters once read the tracks of deer, moose, and bear printed in the soil of the forest floor.... Our first writing, clearly, was our own tracks, our footprints, our handprints in mud and ash pressed upon the rock.[16]

As David Abram reminds us, the petroglyphs of ancient cultures with images of prey animals and rain clouds, though shifting our sensory participation away from the voices and gestures of the surrounding landscape toward our own human-made images, still prompted the human senses inherence beyond the strictly human sphere. Open to and corresponding with a world, discourses were thus embedded in the encompassing speech or logos of an animate earth. It may then come as no surprise that Pien has based his work, to begin with, on *The Classic of Mountains and Seas*, which draws from the rich and detailed fables of geographical and cultural accounts in pre-Qin China.

Lately though, Pien has moved away from his "calligraphic" or "pictographic" drawing and collage to a practice increasingly using paper-cuts and paper itself as a defining principle of his large-scale environments, and rather relying on video and sound, both so-called ephemeral media. As I understand it, this shift may have been prompted by the realization that a culture, which is profoundly informed by alphabet instead of voice, encourages an intellectual distance and estrangement from the non-human environment. For centuries, indigenous cultures have displayed, much more than our modern Western 'civilization', a reciprocity and solidarity, even respect and reverence, for the other species inhabiting their lands. "They maintained a relatively homeostatic or equilibrial relation with their local ecologies for vast periods of time, deriving their necessary sustenance from the land without seriously disrupting the ability of the earth to replenish itself."[17] In just a few centuries of European settlement across many parts of the world, much of the original abundance of the continents has been lost: clear-cutting of forests, over-hunting of animals, depletion of soils and pollution of drinking water sources. According to Abram, "European civilization's neglect of the natural world and its needs has clearly been encouraged by a style

pp 34–35
Ad Infinitum (detail),
1999–2010,
ink and Flashe
on panelled paper,
3.92 x 1.97 m

pp 36–37
Ad Infinitum
(installation view),
1999–2010
ink and Flashe on
panelled paper
3.92 x 1.97 m

Paper Tigers & Surround Scrolls

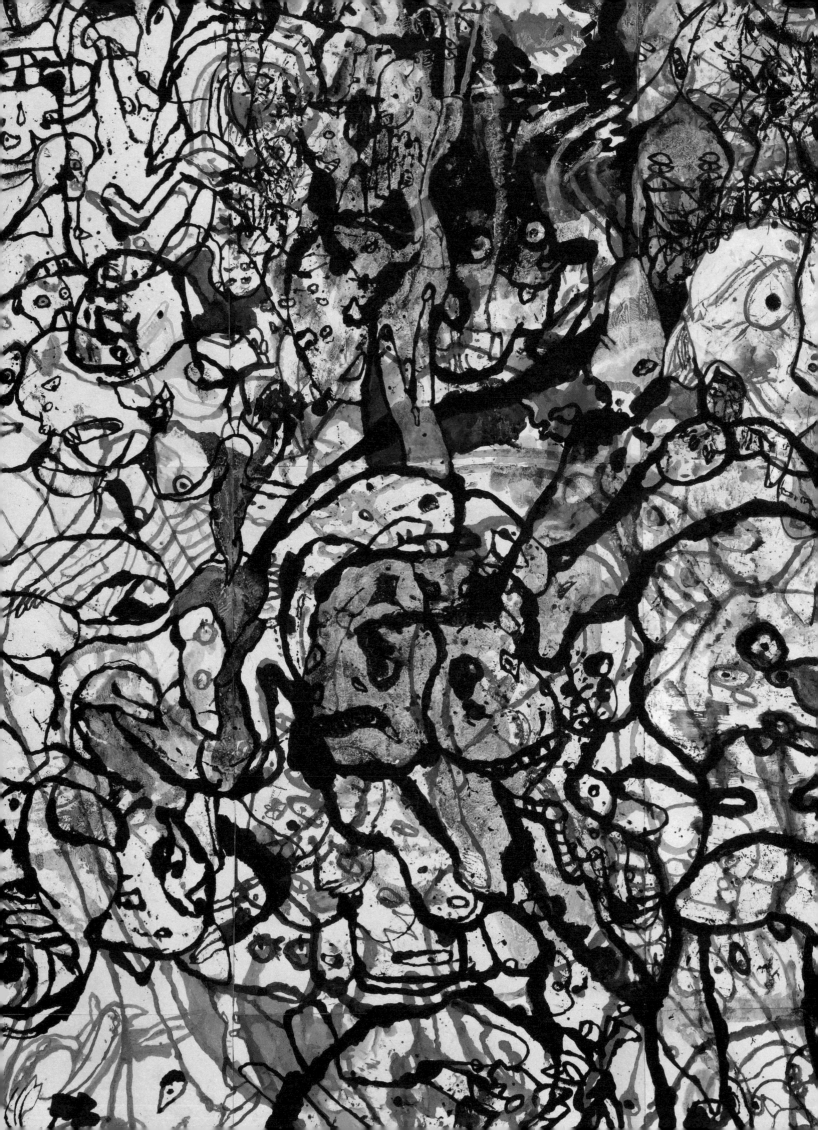

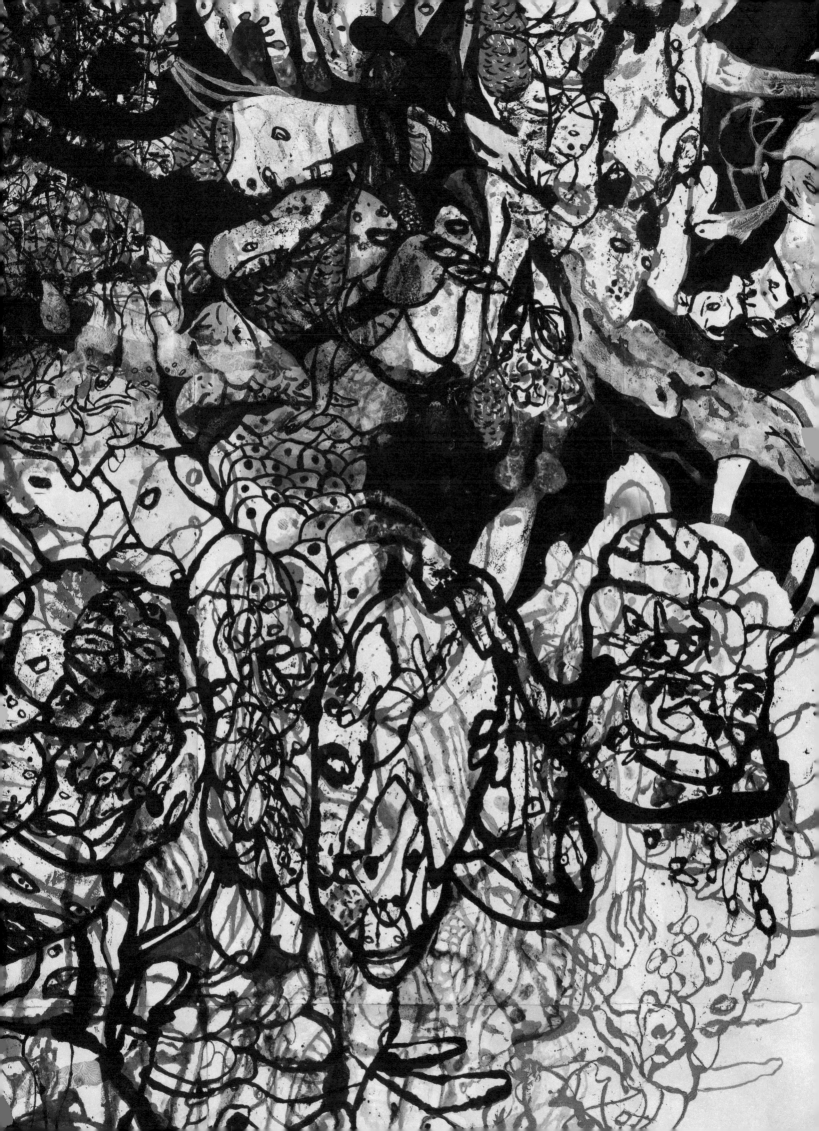

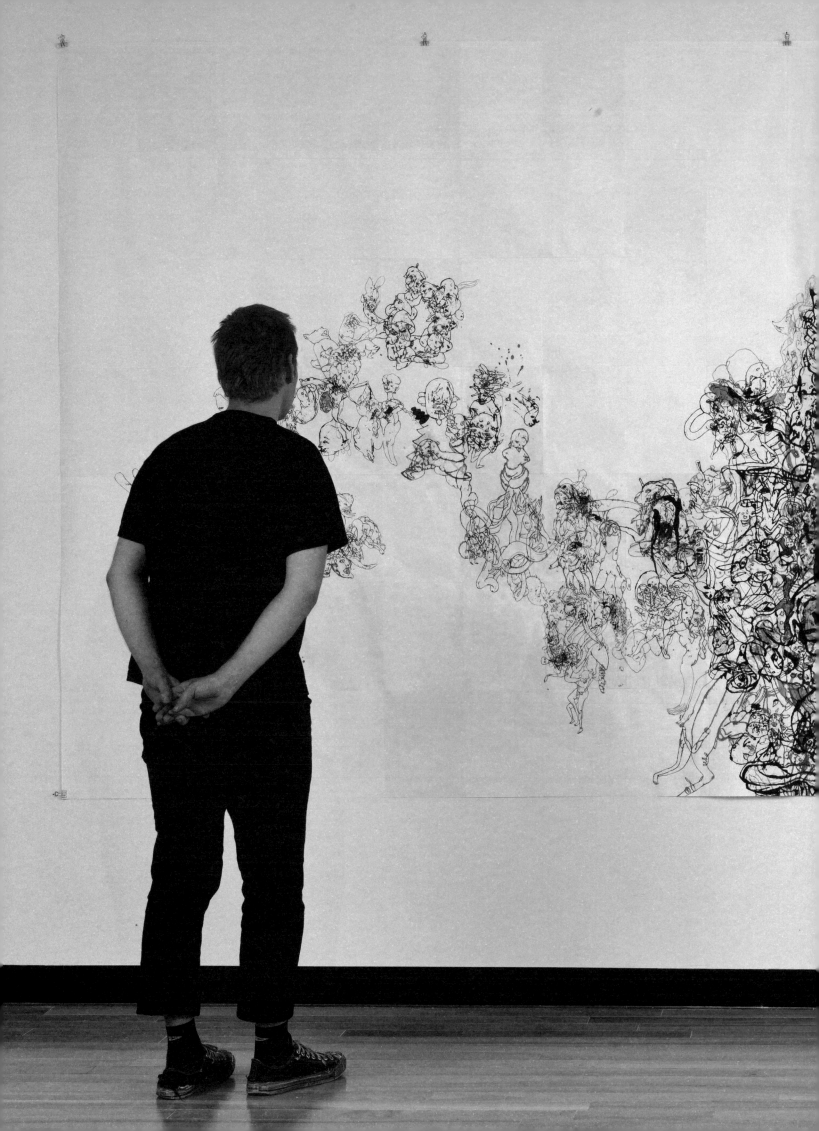

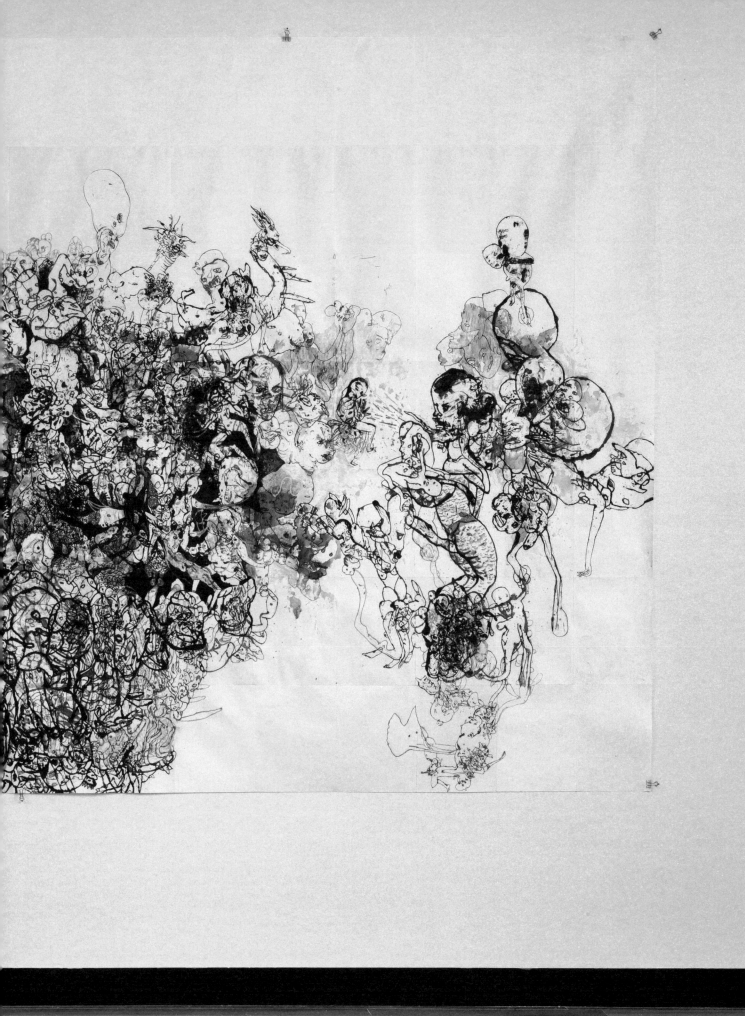

of awareness that disparages sensorial reality, denigrating the visible and tangible order of things on behalf of some absolute source assumed to exist entirely beyond, or outside of, the bodily world."[18]

PAPER AS A MEMBRANE OF THE WORLD

In Pien's recent large-scale paper installations, such as *Source*, 2012, shown at the 18th Biennale of Sydney and *Imaginary Dwelling*, 2013, at the 5th Moscow Biennale—the two biennales he participated in at my invitation—the viewers are encouraged to enter the work in order to engage and explore its layered labyrinthine interior. Surrounded by the projections and sounds inside the paper, they hardly notice their own shadows becoming part of the play, but may come to interpret the content, contributing to effective changes in the world at large, because Pien's seductive and evocative environments ultimately point us to a critical analysis of world affairs and of the depletion of the earth. A simulacrum of the interfolding of lives and experience with a world now separated from us, a form of consequential continuity is sketched out in his graphic apprehension.

Made of Shoji paper from Japan, translucent glassine and waterproof Tyvek, *Source* was partly set in motion by a reading of Merrell-Ann S Phare's book *Denying the Source* and conceived as a collaboration with Tanya Tagaq, an Inuit throat singer from Cambridge Bay (Ikaluktuutiak), Nunavut, Canada, on the south coast of Victoria Island. Asking Tagaq to imagine and sing the sounds of Australian deep-sea creatures, Pien seems to relate *Source* with his earlier fascination with water ghosts. This time, however, the work obliquely draws a connection between water ghosts and the crisis of First Nations' water rights in Canada and throughout North America. Phare's book calls for a new water ethic with respect for indigenous demands for access to waters they depend on:

Oil and gas, mining, ranching, farming and hydro-development all require enormous quantities of water, and each brings its own set of negative impacts to the rivers, lakes and groundwater sources that are critical to First Nations. Climate change threatens to make matters even worse.[19]

Imaginary Dwelling appeared as glowing from within through the use of transparent mylar and the overall projection onto a tent fabric. The shape of the white tent (5.2 metres in diameter and 5.2 metres in height (Moscow version) and 3.8 metres in height (McIntosh Gallery version) is inspired by the tents in Shuvinai Ashoona's drawings that depict panoramic views of her Inuit settlement at Cape Dorset—where Pien spent time as an artist-in-residence.[20] In her meticulous ink and pen renderings, Ashoona very sensitively echoed her reality with an animistic landscape dotted by simple houses and tents. Provisional and fragile, the structures afforded a domestic space sheltering inhabitants from the extreme climatic conditions while negotiating their traditional ways of living without culturally appropriate housing. The tent is a mobile and portable home-on-the-go—a home away from home. For years, this simple construction was a safe-haven for many travellers: quick and easy to set up, affording an intimate as well as a social space that could efficiently accommodate basic, essentially life-sustaining amenities. Some were used during the warmer months when gathering and hunting took place.

Imaginary Dwelling is informed by a consciousness of the harsh effects of post-war housing programs on native land but also by an appreciation of the ingenuity of mobile-dwellings in the Canadian Arctic. In his classic book *Seasonal Variations of the Eskimo,* Marcel Mauss argued that a strong relationship exists between the spatial organization of the traditional Inuit house forms and the social morphology of the families they shelter. His ideas are a poignant reminder of the need to take cultural factors into account when developing aboriginal housing policy:

> What happens when individuals are forced to inhabit houses that are designed around another culture's concepts of family life? Do they alter their lives to match those of their new architectural surroundings? Or do they rigidly adhere to their traditional routines and practices in order to retain their cultural identity?[21]

pp 40–41
Source, 2012
video projection, sound by Tanya Tagaq, paper, Tyvek, clear mylar, rope
variable dimensions

In this way, *Imaginary Dwelling* is conceived as a poetic contemplation of the complex and pressing social realities First Nations' communities are facing daily as a consequence of past colonization and current climate change.

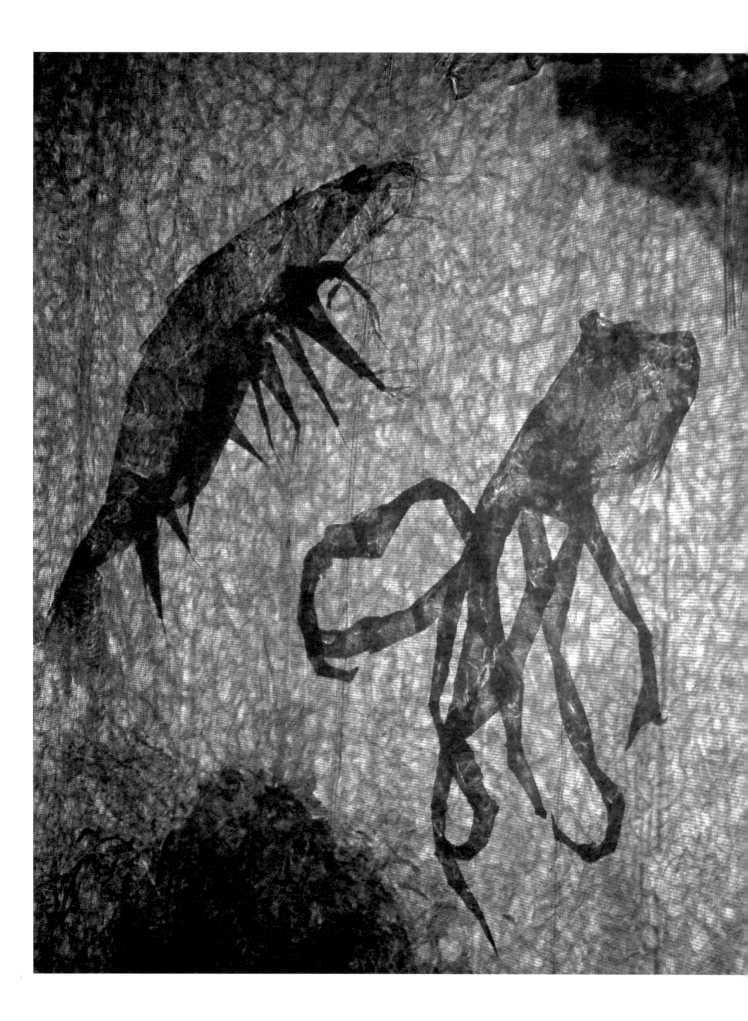

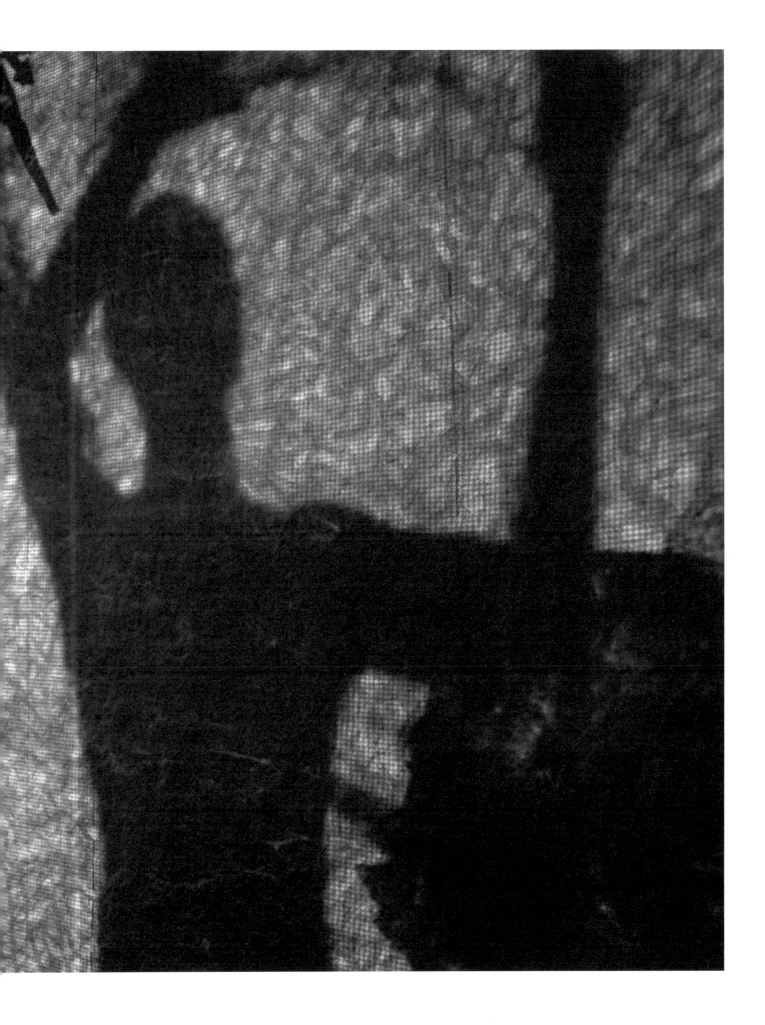

Moreover, *Imaginary Dwelling* contains a second space made out of hand-cut transparent mylar and resembling frost. This circular structure encloses a miniature townscape: a number of small, foldable transparent houses are placed on an undulating ground that is made from the same material and fashioned to resemble an icy and rocky landscape. Two videos are projected onto the tent walls surrounding the interior landscape. One depicts an Inuit Elder carrying her granddaughter on her back in an *amauti*—a pouch for carrying infants—who seems entirely absorbed by the creation of these model houses, while rocking the child safely tucked in behind her. The other video shows the silhouette of a pre-teen girl completely riveted by a play with the same mini-houses. According to Pien, her youthful stature and long hair allude to familiar characters from fairy tales. Above the townscape, 13 suspended clear disks and mirrors slowly revolve like the changing phases of the moon. The disks' surface reflects video images onto the tent's walls and, as the disks rotate, the video images move around. The mirrors in Pien's installation also remind us of Mauss' observation that "architecture mirrors social life". In Inuit societies, "the intensive use of communal space was a material expression of the importance of collective life".[22] And in a play of light and shadow, visitors engage with the fabulous narrative drawn by coloured light on the thin paper-like surface. In this way, the visitors' shadows within are also projected outward and become part of this uncanny play, conflating illusion with reality and collapsing different moments in time and space. Again there is the interpenetration of worlds in a perception akin to the life of unseparated things that protected and sustained both the human world and the world of all living entities.

FROM SCROLL AND
DRAWING TO STORYTELLING
AND DWELLING

Thus we cover the universe with drawings we have lived. These drawings need not be exact. They need only to be tonalized on the mode of our inner space. But what a book would have been written to decide all these problems! Space calls for action, and before action, the imagination is at work. It mows and

Ed Pien: Luminous Shadows

ploughs. We should have to speak of the benefits of all these imaginary actions.[23]

Gaston Bachelard, in his book *The Poetics of Space,* proposes that one's dwelling is a place that makes dreaming and imagining possible. In *Imaginary Dwelling,* boundaries of present and past essentially coincide, and the transparent, ghostly model houses become a metaphor for memory, trauma and loss but also of hope for a better future. As Pien tells me:

Part of my strong motivation to create *Imaginary Dwelling* is derived from workshops I led with migrants, refugees and asylum seekers in England. They made model houses as a reminder of the homes they had to leave behind and/or the homes they dream to live in one day in the future.[24]

The way in which we live in our house is called dwelling: to be at home in a fixed and stable place, to be rooted in it and belong to it. Migration turns this sense of secure shelter upside down so that exiles and migrants feel themselves as eternal fugitives scattered or dispersed in a menacing environment–currently, in Europe, thousands of refugees arrive every day from the conflict zones of Syria, Somalia, Afghanistan, Iraq and Libya among others. According to Bachelard, "man feels comfortable in a quite direct sense in the warmth of his nest, and this gives him a quite elemental 'joy of dwelling' in which man feels kinship with animals". He then approvingly quotes a statement by Vlaminck: "'The well-being I feel, seated in front of my fire, while bad weather rages out-of-doors', (as it happens to do while I write these words!) 'is entirely animal. A rat in its hole, a rabbit in its burrow, cows in the stable, must all feel the contentment that I feel.' In this context he praises the warm 'maternal features of the house'."[25]

It concerns the primeval existential experience of life: an inner enclosed and warm space is separated from an outer chaotic and often hostile world. It collects and enables us to daydream in peace. Bachelard even considers the house's main benefit that it allows us to follow our imaginative dreams. "And from the dreams produced by the power of imagination there comes into being the 'oneiric house', that 'crypt of the house that we are born in... our house, apprehended in

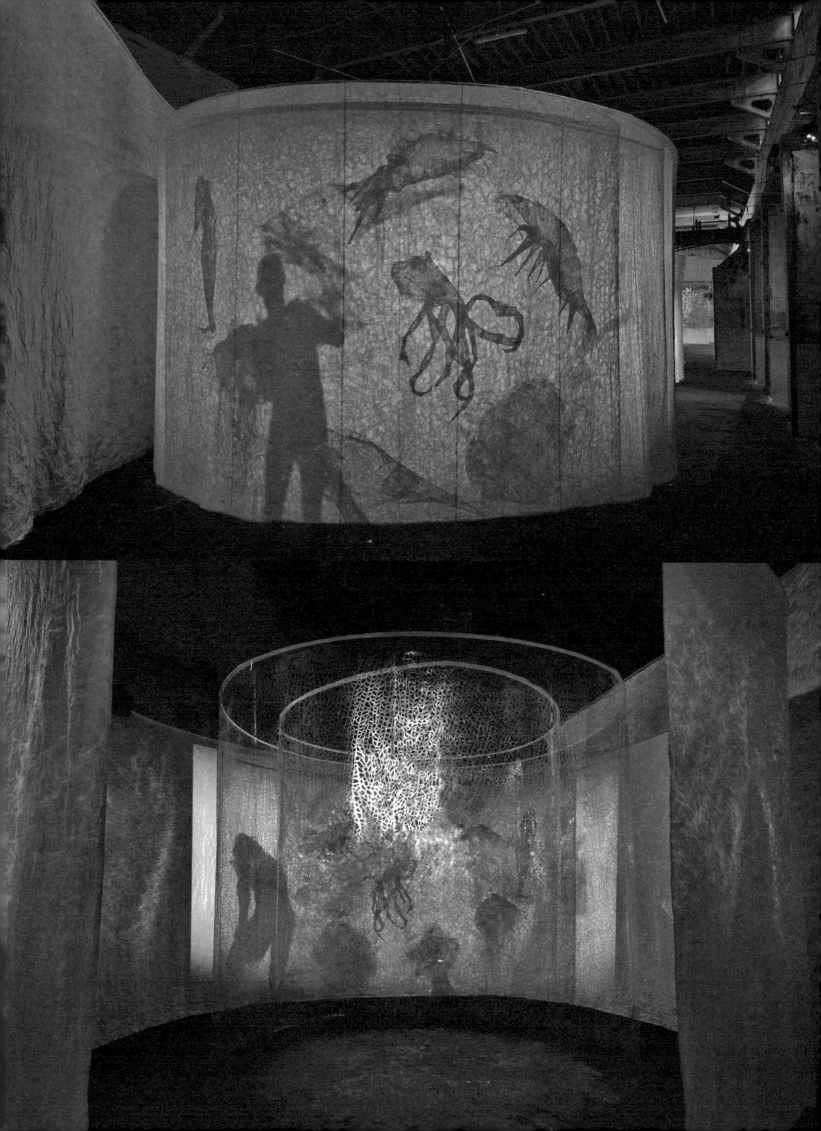

its dream potentiality, becomes as a nest in the world'"—a womb-like, matrixial space.[26]

This maternal warmth and intimacy is expressed in *Imaginary Dwelling* by the figure of the grandmother embodying a past, and the children a future in an animate landscape, filled with spirits, that is projected on an "oneirically definitive house retaining its shadows".[27] Bachelard writes furthermore:

> All I ought to say about my childhood home is just barely enough to place me, myself, in an oneiric situation, to set me on the threshold of a day-dream in which I shall find repose in the past. Then I may hope that my page will possess sonority that will ring true—a voice so remote within me, that it will be the voice we all hear when we listen as far back as memory reaches, on the very limits of memory, beyond memory perhaps, in the field of the immemorial.[28]

It may be that we need to see Pien's work as echoing Bachelard's thinking as "a house constitutes a body of images that give mankind proofs or illusions of stability".[29] As the artist expounds curiosity, wonder and enchantment, he focuses on the oneiric, strange and sometimes grotesque as a means of overcoming fears and vulnerabilities, opening the way and creating the potential to act. By questioning and challenging the concept of normality and reconsidering preconceived notions of difference, it becomes possible to celebrate new and diverse ways of being in the world.

In particular, it is in Pien's art of layering traces that the reader can find the intricacy of memory and imagination. As a dreamer of refuges—be it a hole, a nest, a tent, an igloo—the artist creates with the primal imaginary taken from childhood homes and tales, embedded deep inside of us. Pien incorporates the monstrous in order to extend and expel the normative anxieties they invoke. In his drawing-based works, images of strange and hybridized figures defy swift or simple reading, and have recently, with the introduction of the projected and moving image, become even more intricate and layered with overlapping gestural outlines of dense and agitated creatures. Yet, it is in the unending drawing process itself and the alternate imprinting of these marks and traces, over and over again, that Pien's work has known a profound evolution from alphabet to voice, from tracing to storytelling—and this, remarkably, in an almost reverse

Source, 2012
video projection, sound
by Tanya Tagaq, paper,
Tyvek, clear mylar, rope
variable dimensions

movement from the work of Copper Thunderbird in the early 1970s. At that time there was indeed the belief that tracing would contribute to the survival of oral tradition and memory. Different times request different artworks and attitudes: the 1970s were defined by civil rights movements—movements of freedom and empowerment by marginalized groups in society, such as women, black and native peoples, and so on.... Our current era is marked worldwide by ecological disasters and the catastrophic consequences of climate change. Therefore, Pien takes on socio-political problems in a way that corresponds to the new millennium.

Most noteworthy here, in the current process on and of tangible paper, is the translation of Pien's earlier "pictographic" work into the more recent, surround installations with moving image and sound, reconnecting us with the sensorial realm of the earthy world around us, as if the artist had recognized writing to be contributing in some way to civilization's distrust and derogation of bodily and sensorial experience by advocating pure ideas that exist in a non-sensorial realm. This transformation parallels another shift in his work that, initially, had to be perceived voyeuristically by the gazing viewer, standing outside the paper cylinder, but is now seen within the immersive environments of his last scroll-like structures—cylindrical labyrinths in which visitors can use all their senses as though submerged, losing their selves.... In this way, Pien not only lays bare the sources of our contemporary estrangement, established in Western cultures by "the spiritual and religious ascendency of humankind over nature... and by the rational dissociation of the human intellect from the organic world".[30] He also challenges this intellectual distance from the non-human environment that had been ascertained and encourages sensuality and reciprocity so that we can still change the course of the consequences of alienation. From these perspectives, the potential of Pien's large-scale paper projects, *Source* and *Imaginary Dwelling,* suggests not only a sensorial experience and, hence, an activist impulse but also a great contribution to a deeper, relational transformation with attention to each other and to the world we live in.

1 A Carrier Indian, quoted in Jenness, Diamond, *The Carrier Indians of the Bulkley River,* Bureau of American Ethnology, Bulletin 133, Washington, DC: Smithsonian Institution, 1943, p 540; quoted by Abram, David, *Spell of the Sensuous*, New York: Vintage Books, 1996, p 132.

2 From "Valentine", Carol Ann Duffy, http://web.mit.edu/adorai/www/valentine.txt

3 Hearn, Lafcadio, *Some Ghost Stories,* Boston: Little, Brown, and Company, 1906.

4 Ed Pien in conversation with the author, 2012–2013.

5 Ed Pien in conversation with the author, 2012–2013.

6 Nakagawa, Masako, "The Shan-hai ching and Wo: A Japanese Connection", *Sino-Japanese Studies* 15, April 2003.

7 de Zegher, Catherine, "Draw & Tell", *Lines of Transformation by Norval Morrisseau/Copper Thunderbird,* in Drawing Papers 19, The Drawing Center, New York, 2011.

8 The FLASHE range, distributed since 1955 by LeFranc & Bourgeois, is a polymer-based gouache. Its optical characteristics allow the effects of old tempera paints and primitive painting grounds to be reproduced. The paints are matte, lush, velvety and opaque.

9 Ed Pien in conversation with the author, 2012–2013.

10 Ed Pien in conversation with the author, 2012–2013.

11 Ed Pien in conversation with the author, 2012–2013.

12 Ed Pien in conversation with the author, 2012–2013.

13 Pien tells the author: "The quickness of the drawing forces me to work expressively and spontaneously, without much inhibition. I even use a timer to make sure I don't spend more time on each one. If the three-minute session doesn't resolve the drawing in question, I would put this same drawing through another three-minute session a few weeks or months later."

14 Ed Pien in conversation with the author.

15 Gernet, Jacques, quoted by Derrida, Jacques, *Of Grammatology,* trans Gayatri Spivak, Baltimore: Johns Hopkins University Press, 1976, p 123. Quoted by Abram, *Spell of the Sensuous*, p 96.

16 Abram, *Spell of the Sensuous,* pp 95–97.

17 Abram, *Spell of the Sensuous,* pp 93–94.

18 Abram, *Spell of the Sensuous,* pp 95–97.

19 See http://www.rmbooks.com/book_details.php?isbn_upc=
 9781897522615#

20 Pien wrote: "My ties with Inuit artists began in 1999, through Sheila
 and Jack Butler when they introduced me to works by artists from Baker
 Lake. Since that time, I have been paired or collaborated with Inuit artists.
 My drawings were presented with Samonie Toonoo's stone carvings in
 Scream, curated by Nancy Campbell in 2010. I also worked on an AGO
 exhibition design, showcasing Lucy Tasseor Tutsweetok's sculptures.
 Most recently, the installation entitled *Source* included throat-singing
 by Nunavut-born musician, Tanya Tagaq. Her haunting and expressive
 voice spatially, conceptually and emotionally activated the work."

21 Dawson, Peter C, "Seeing like an Inuit family: The relationship
 between house form and culture in northern Canada", *Etudes/Inuit/
 Studies,* 2006, 30(2), pp 113–135.

22 Dawson, *Etudes/Inuit/Studies,* pp 113–135.

23 Bachelard, Gaston, *The Poetics of Space,* trans M Jolas, Boston: Beacon
 Press, 1994, p 12.

24 Ed Pien in conversation with the author, 2012–2013.

25 Bollnow, OF, "Ch. 3, The Security of the House", *Human Space,*
 trans C Shuttleworth, London: Hyphen Press, p 128.

26 Bollnow, *Human Space,* p 127

27 Bachelard, *The Politics of Space,* p 13.

28 Bachelard, *The Politics of Space,* p 13.

29 Bachelard, *The Politics of Space,* p 17.

30 Abram, *Spell of the Sensuous,* p 95.

IMAGINARY DWELLING

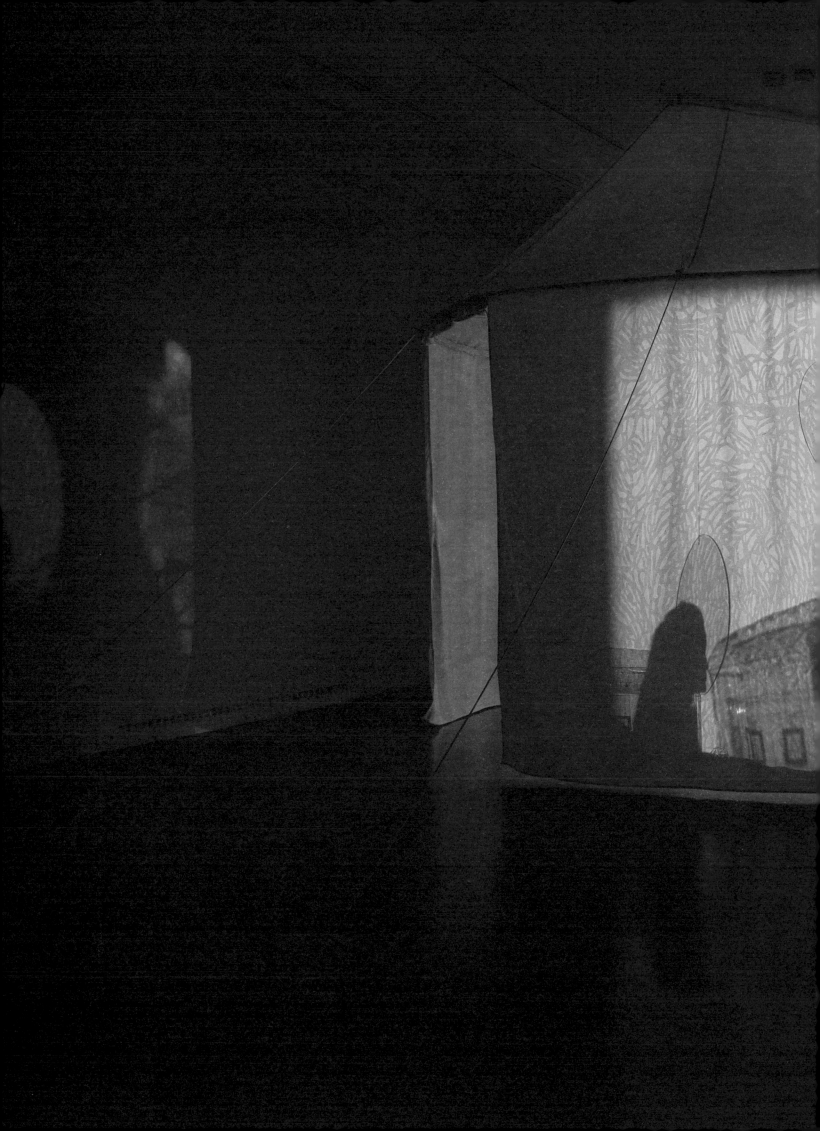

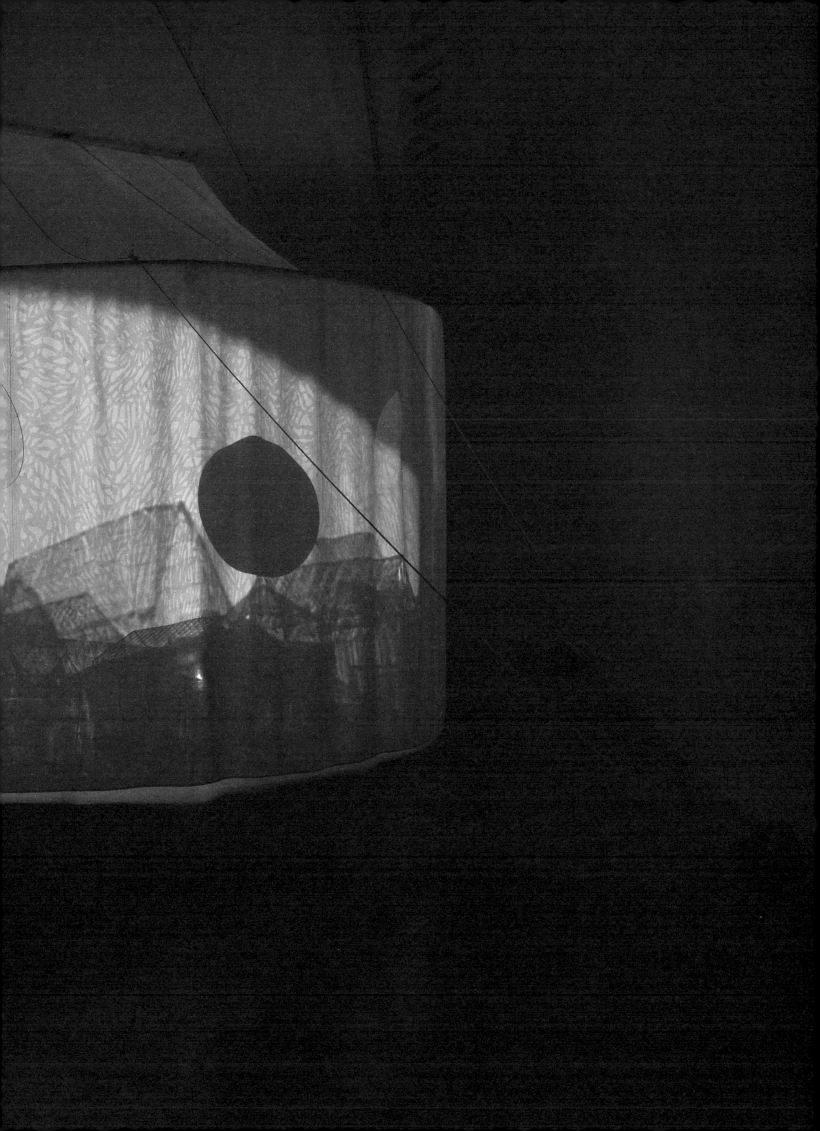

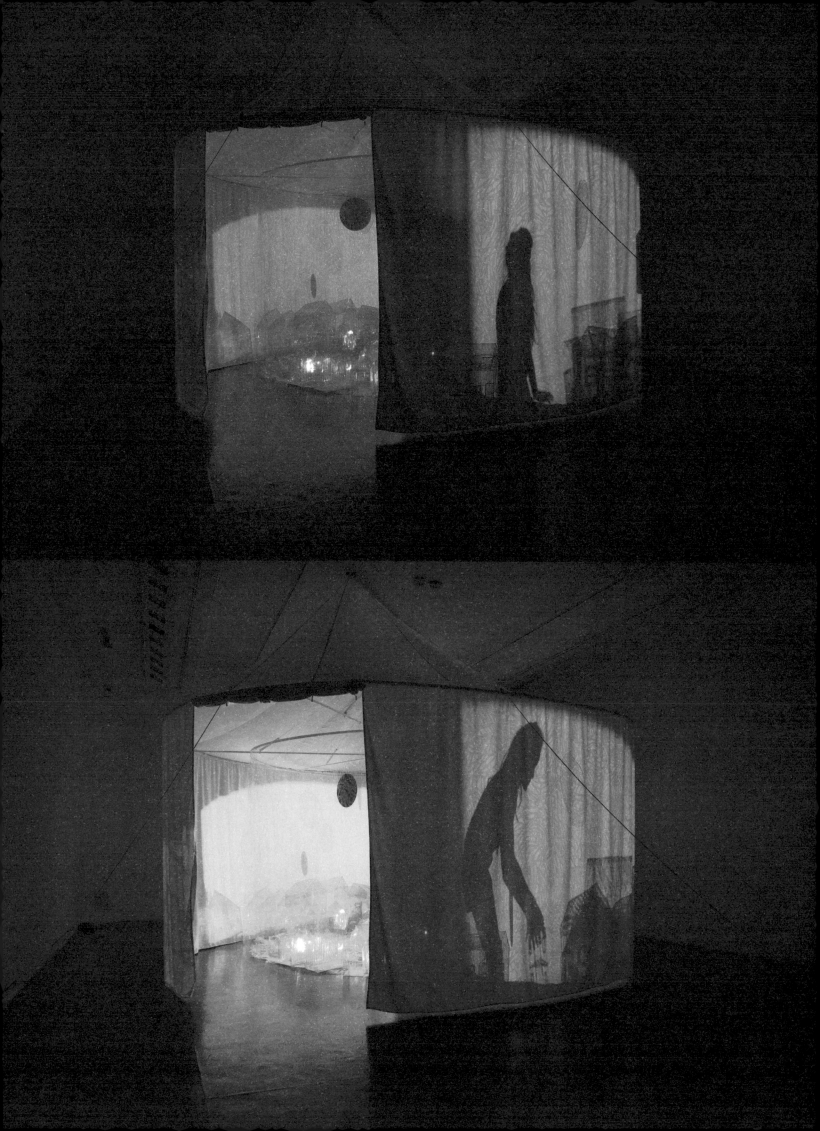

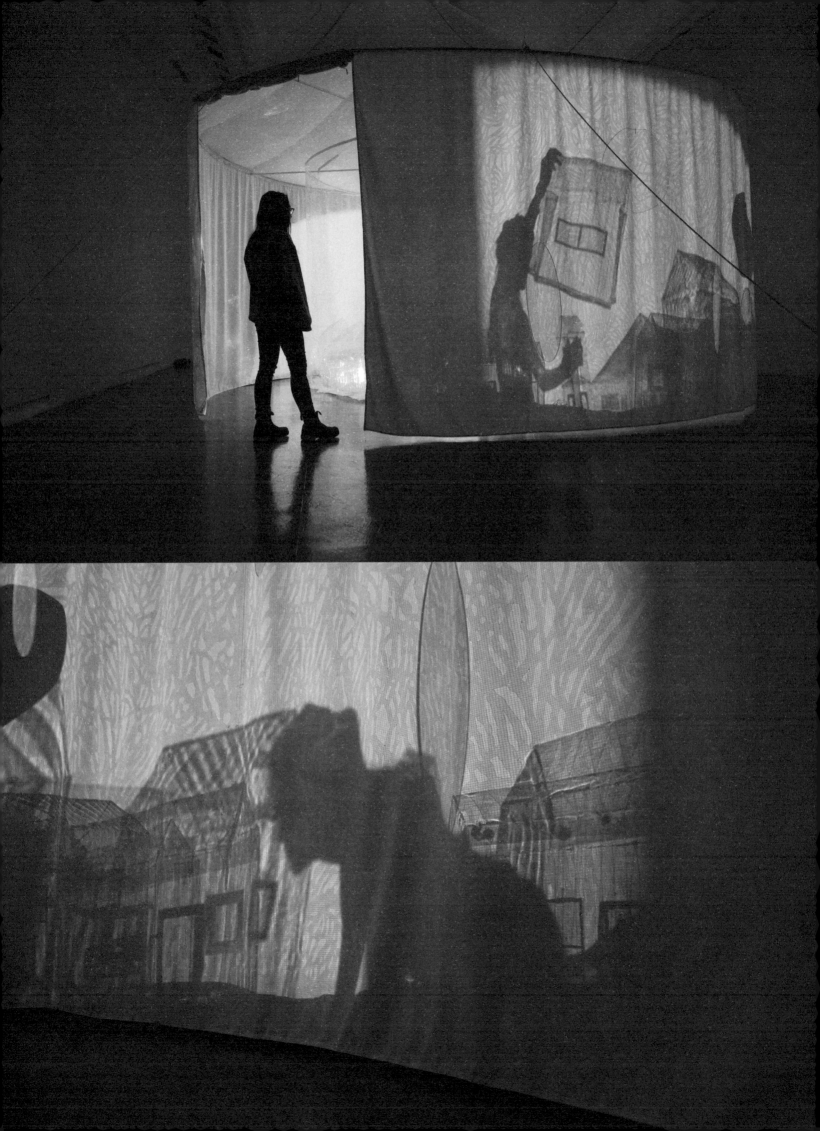

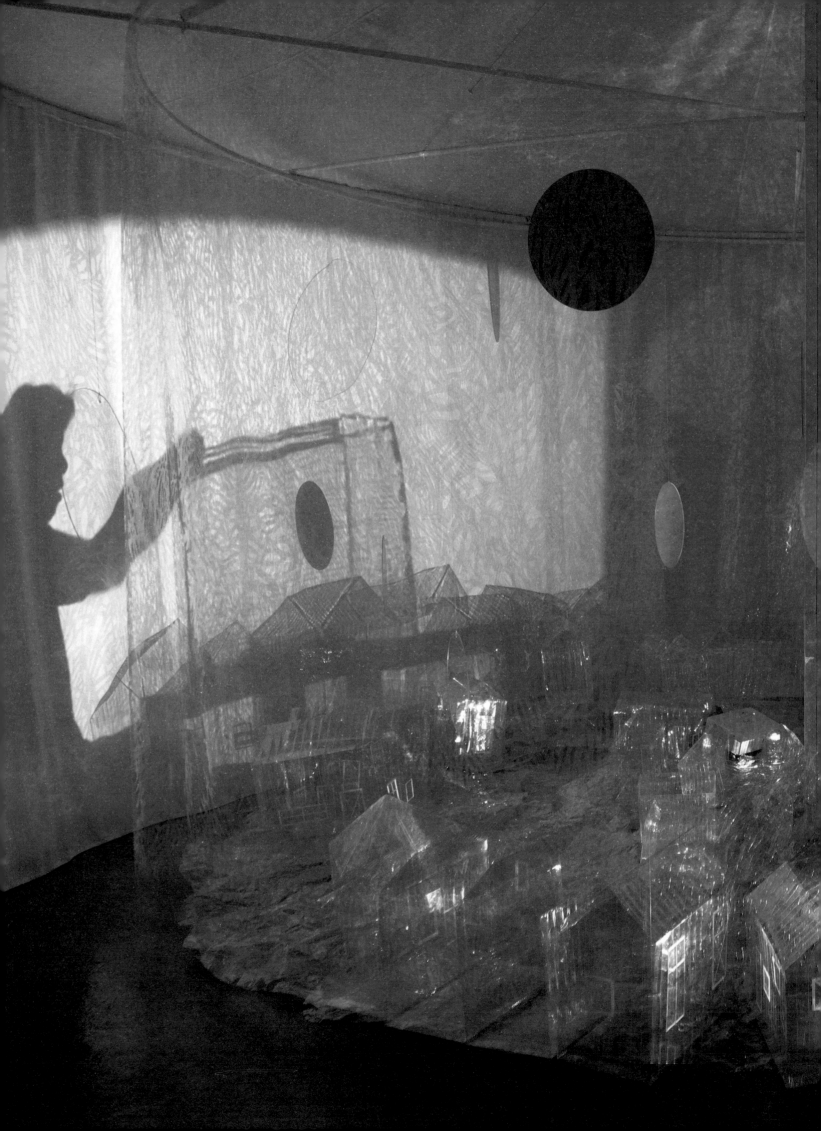

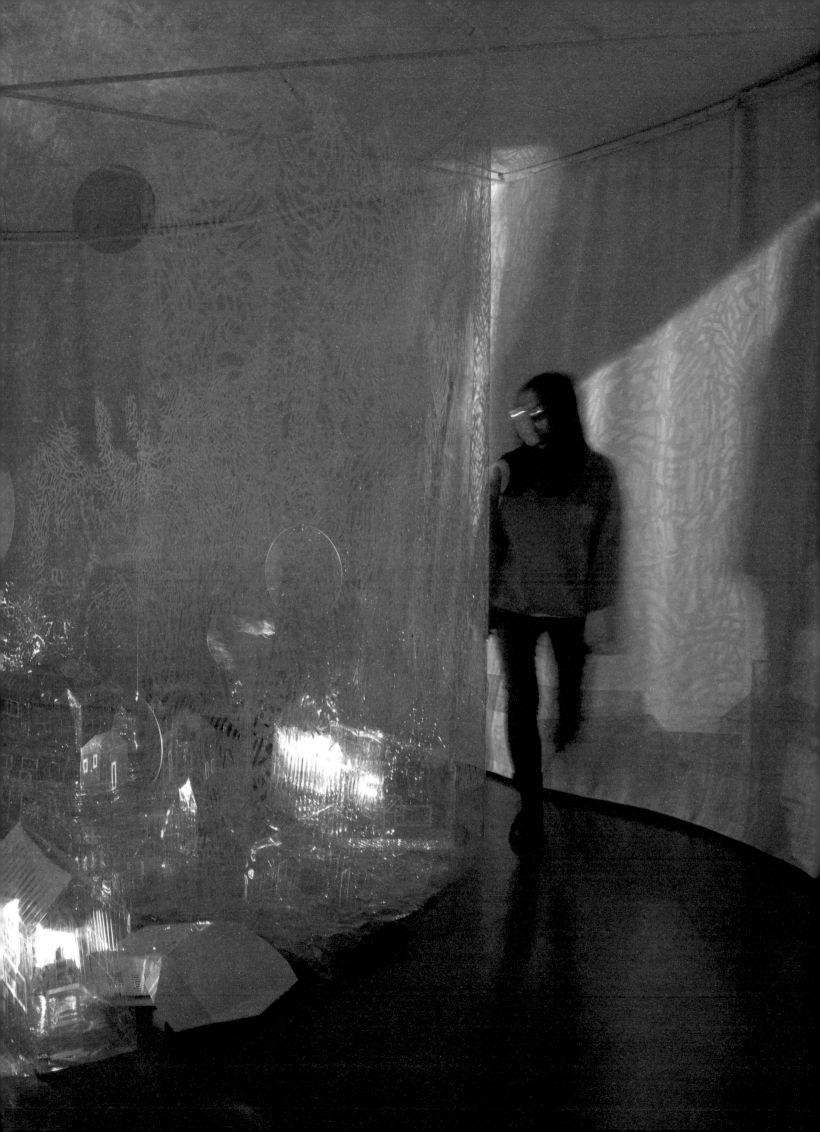

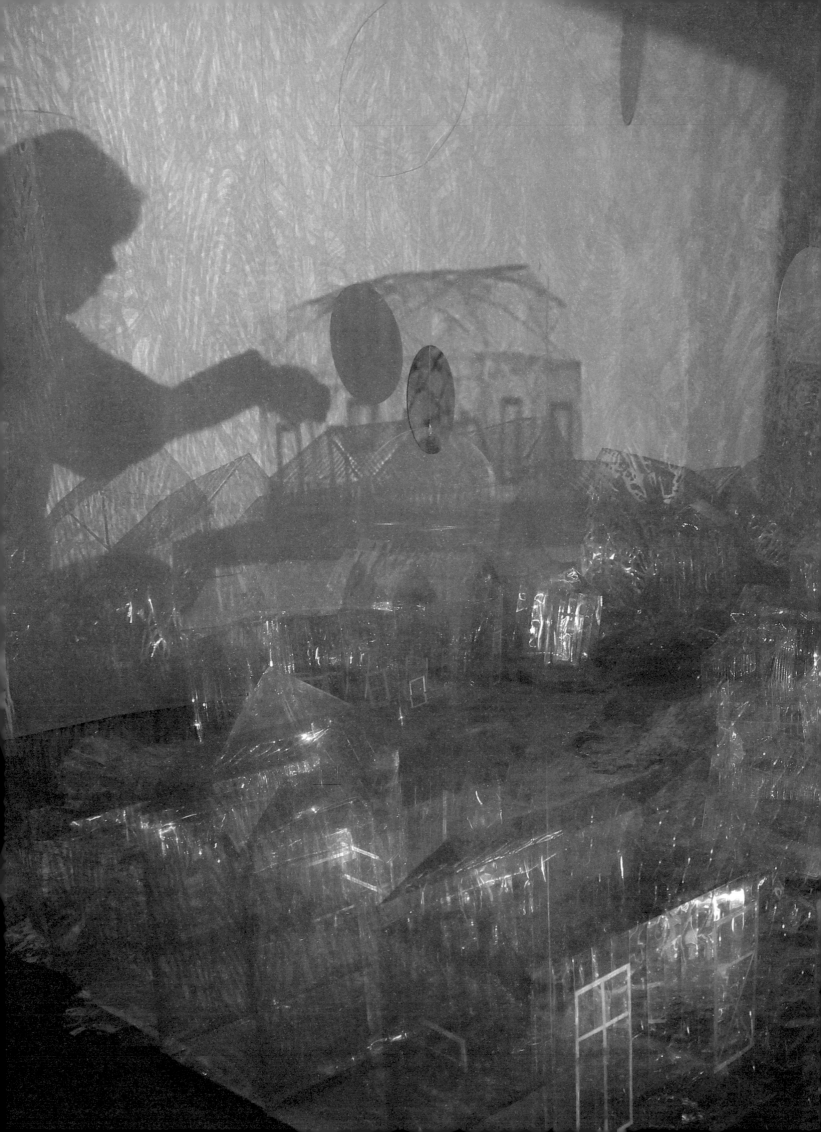

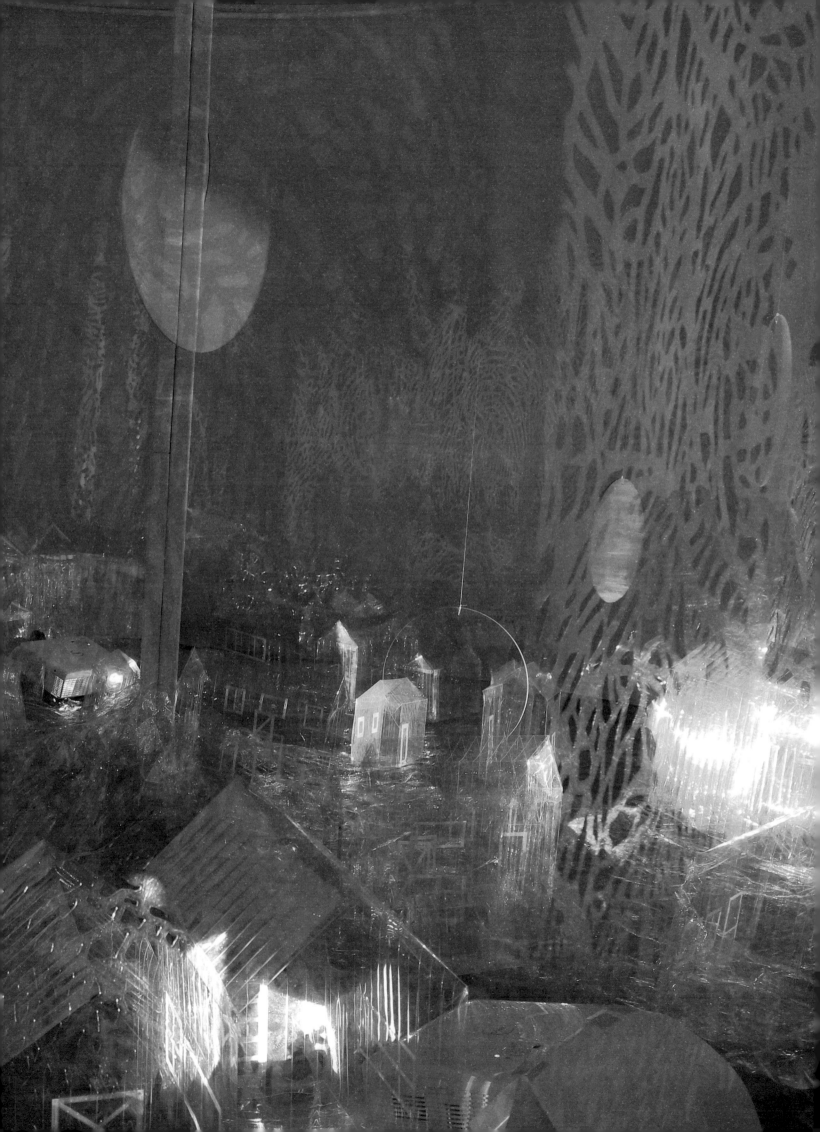

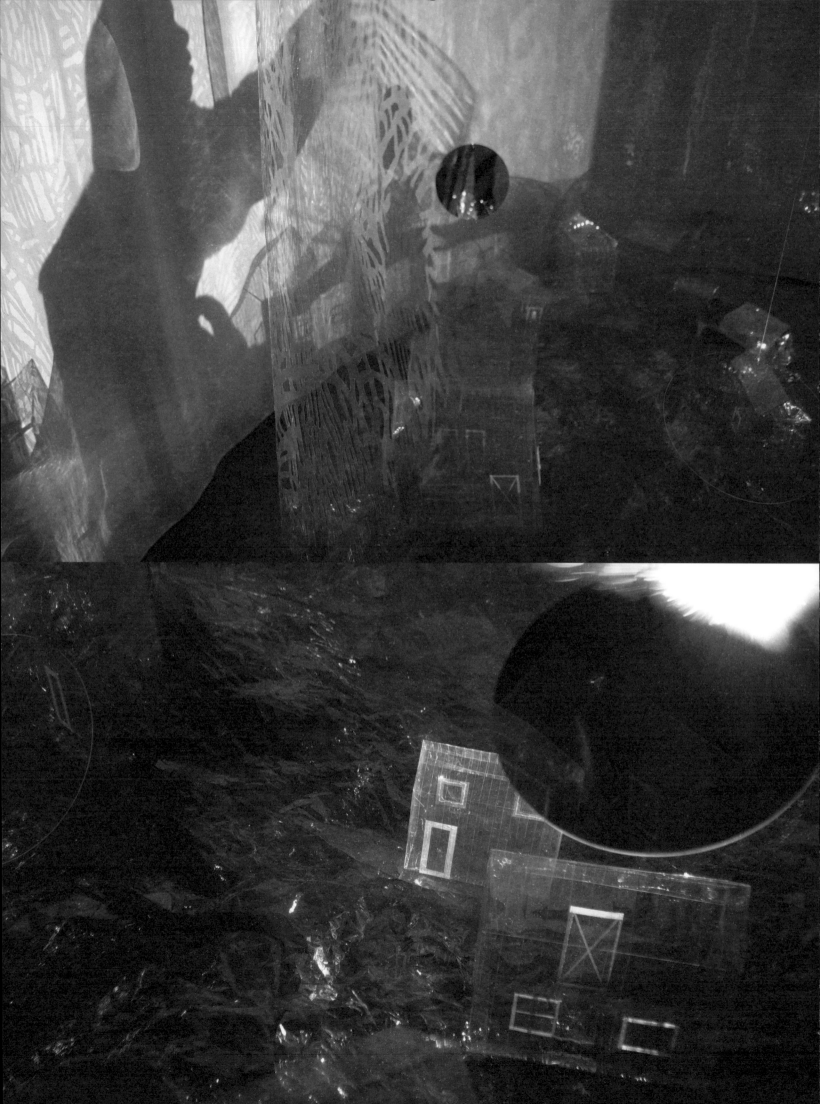

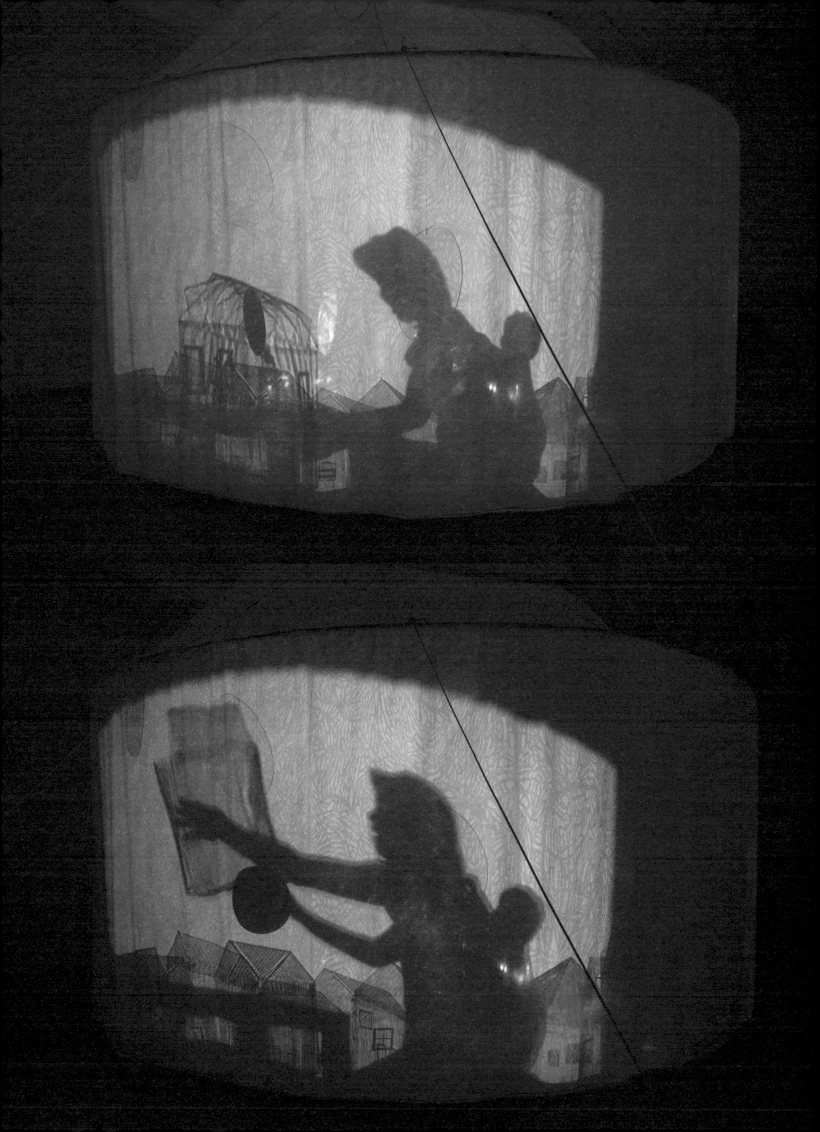

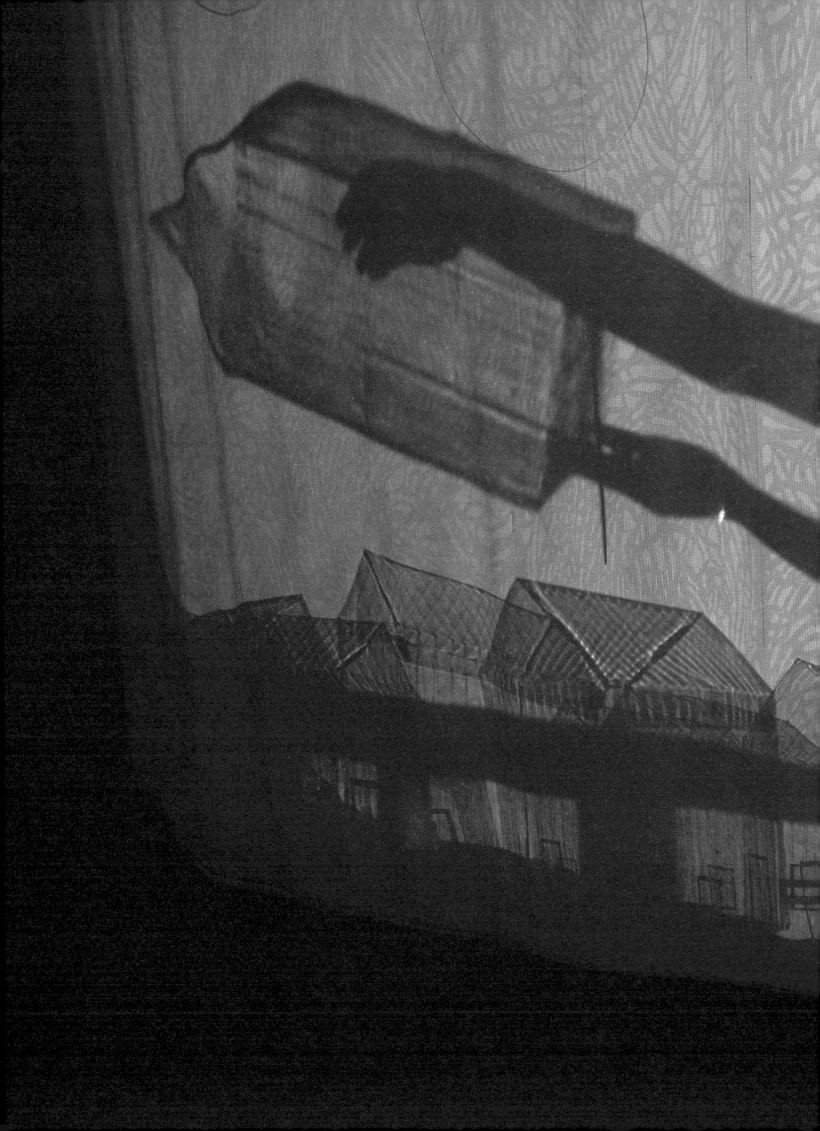

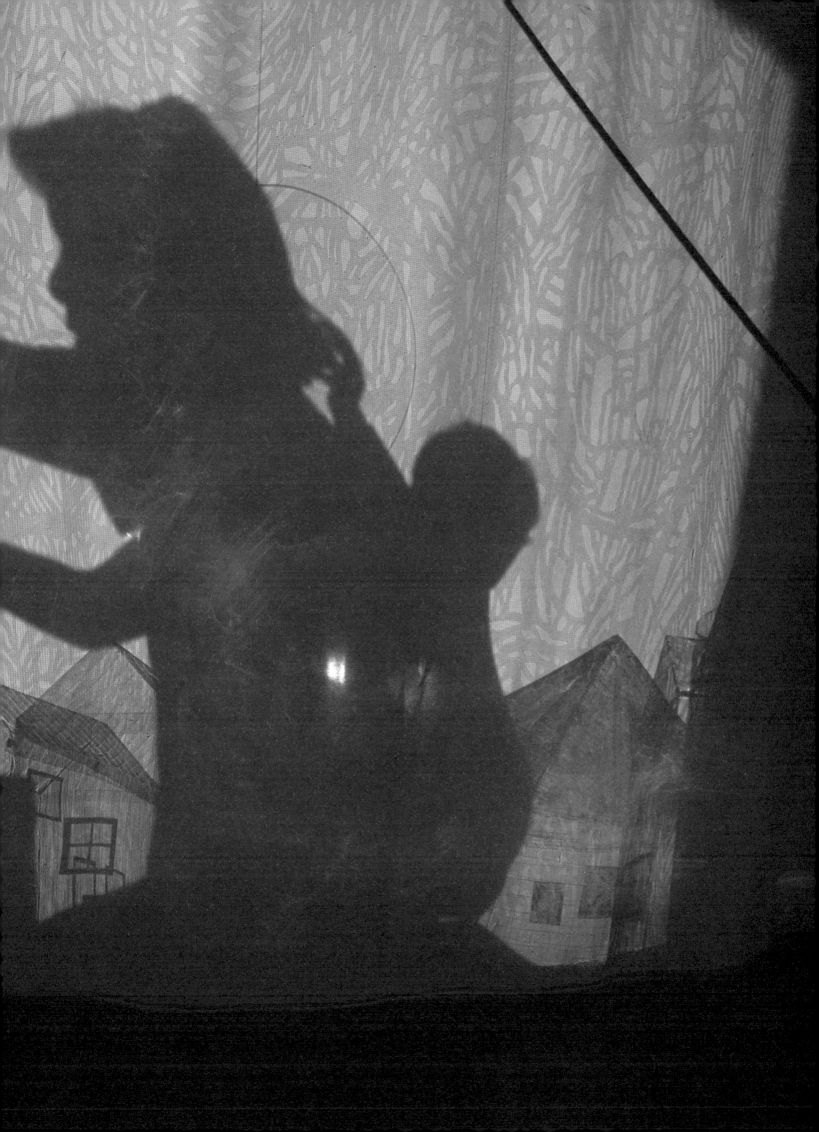

SPECTRAL DRAWINGS

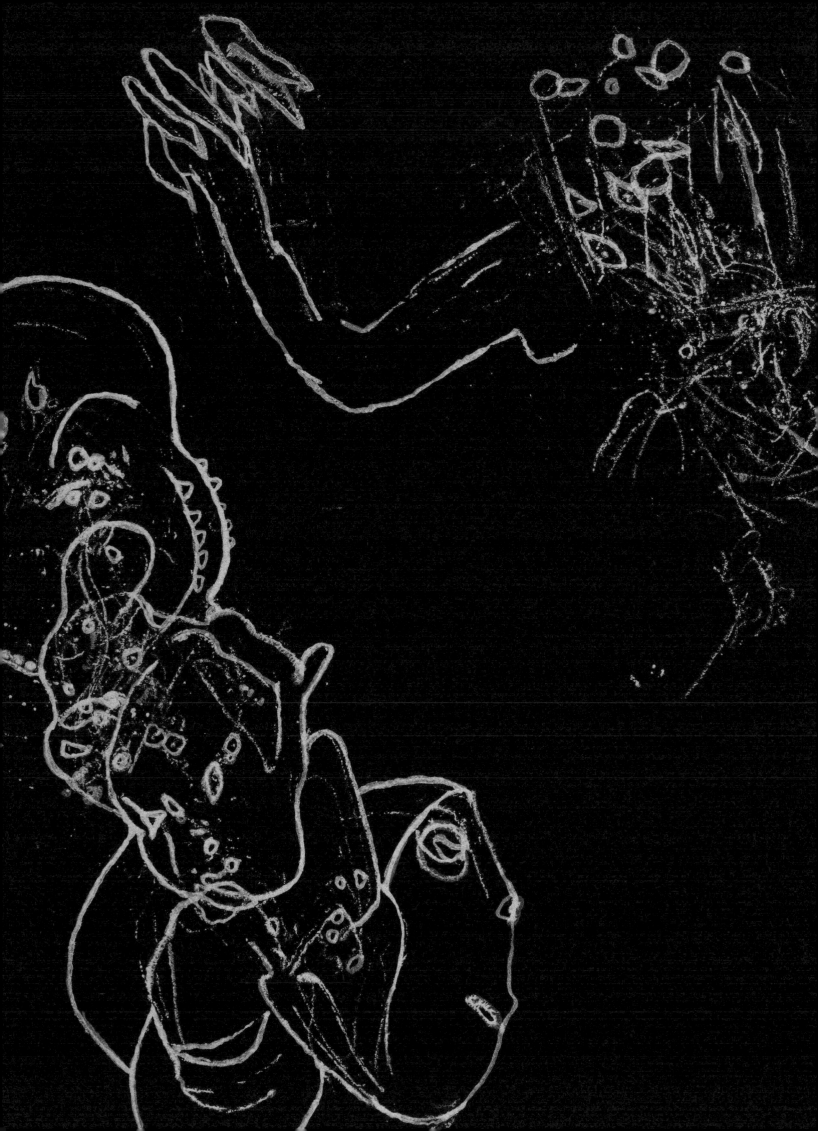

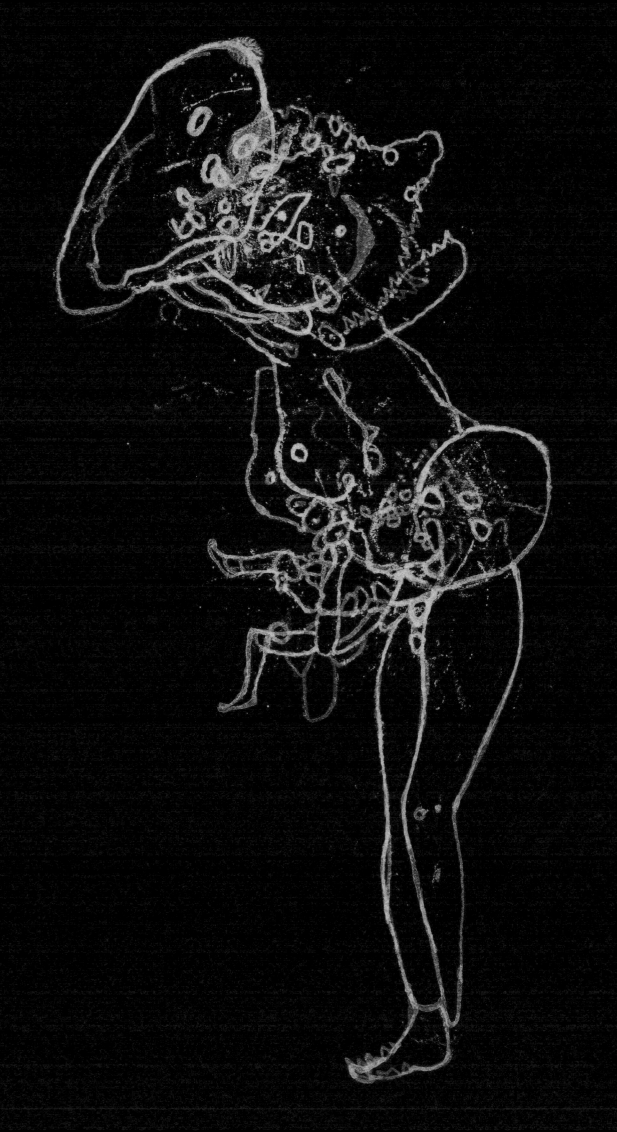

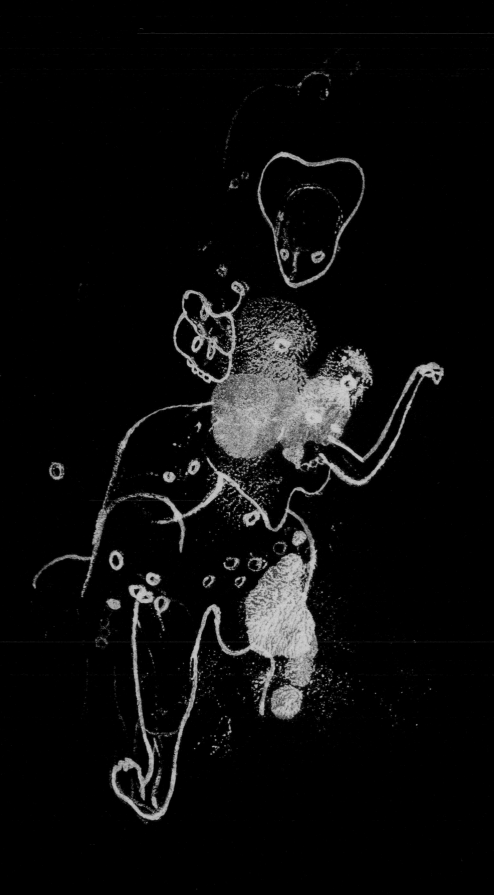

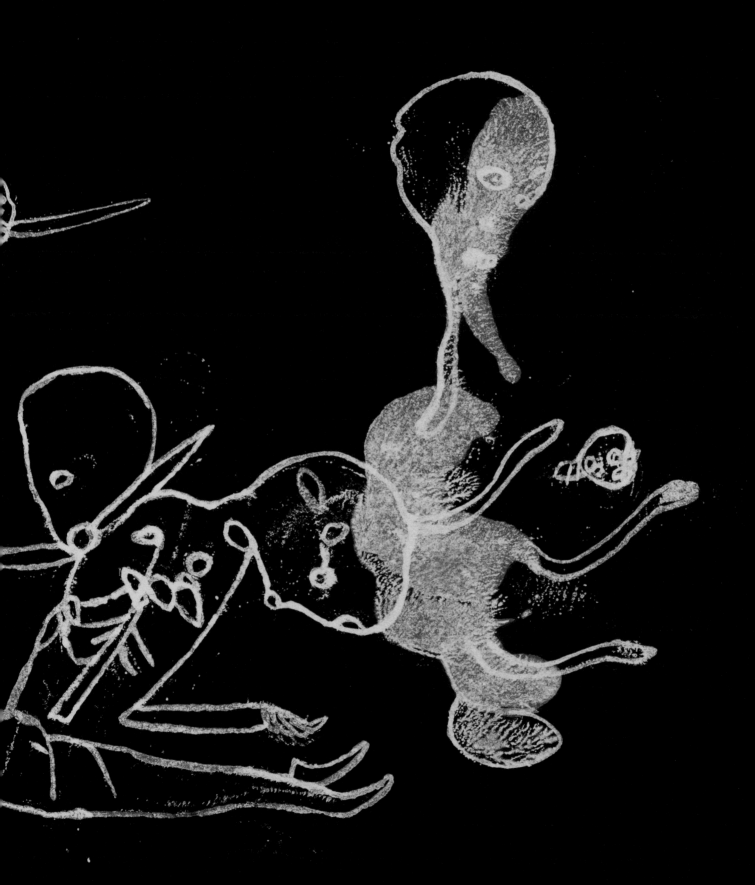

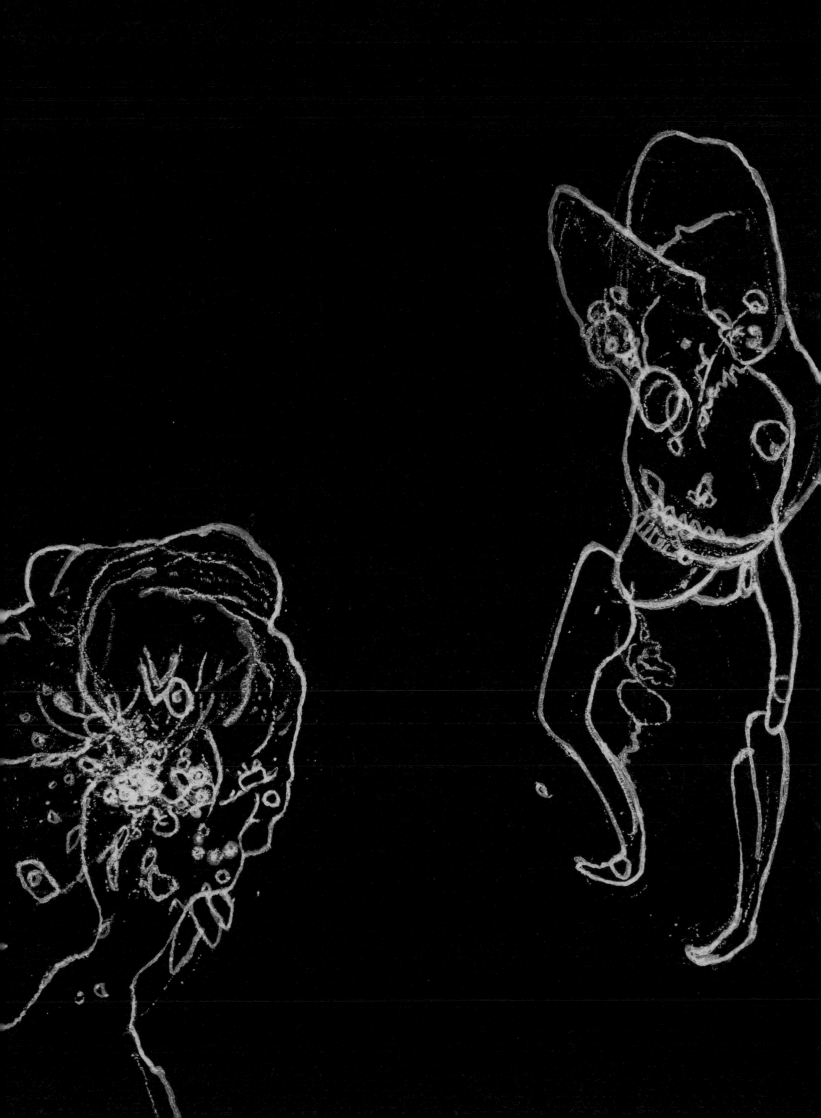

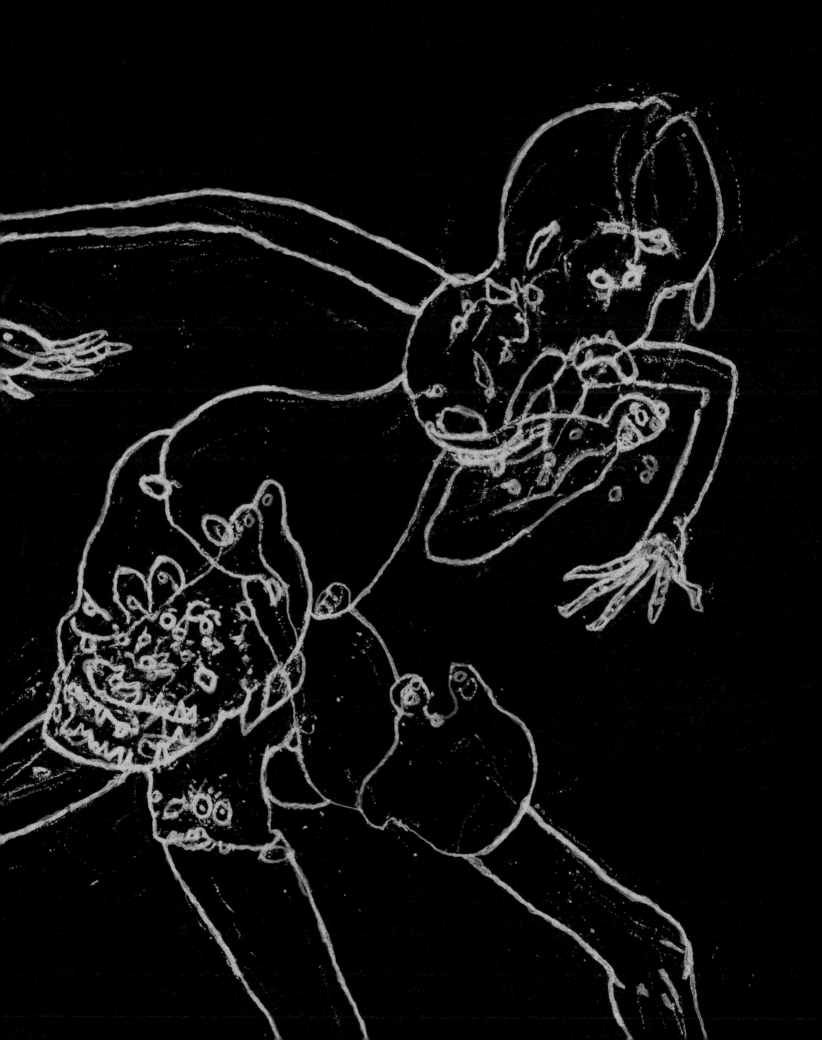

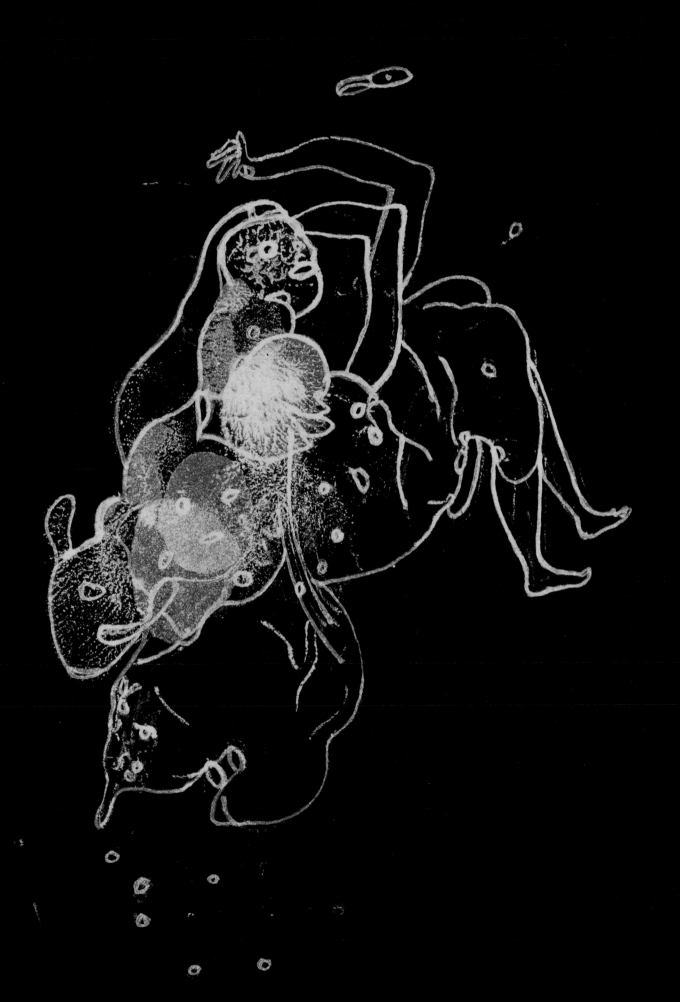

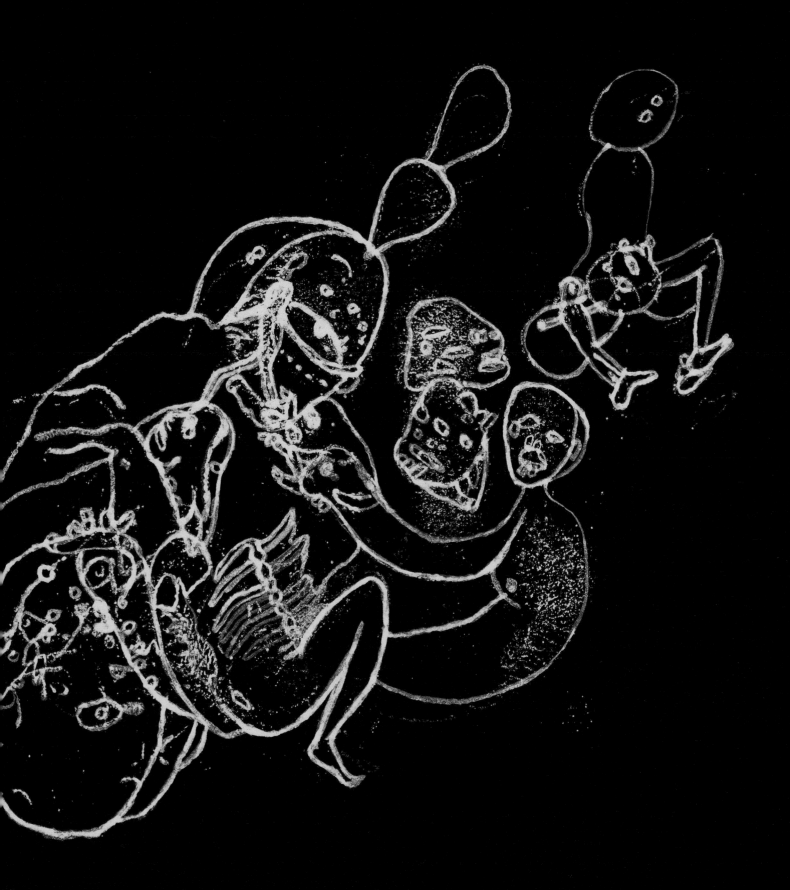

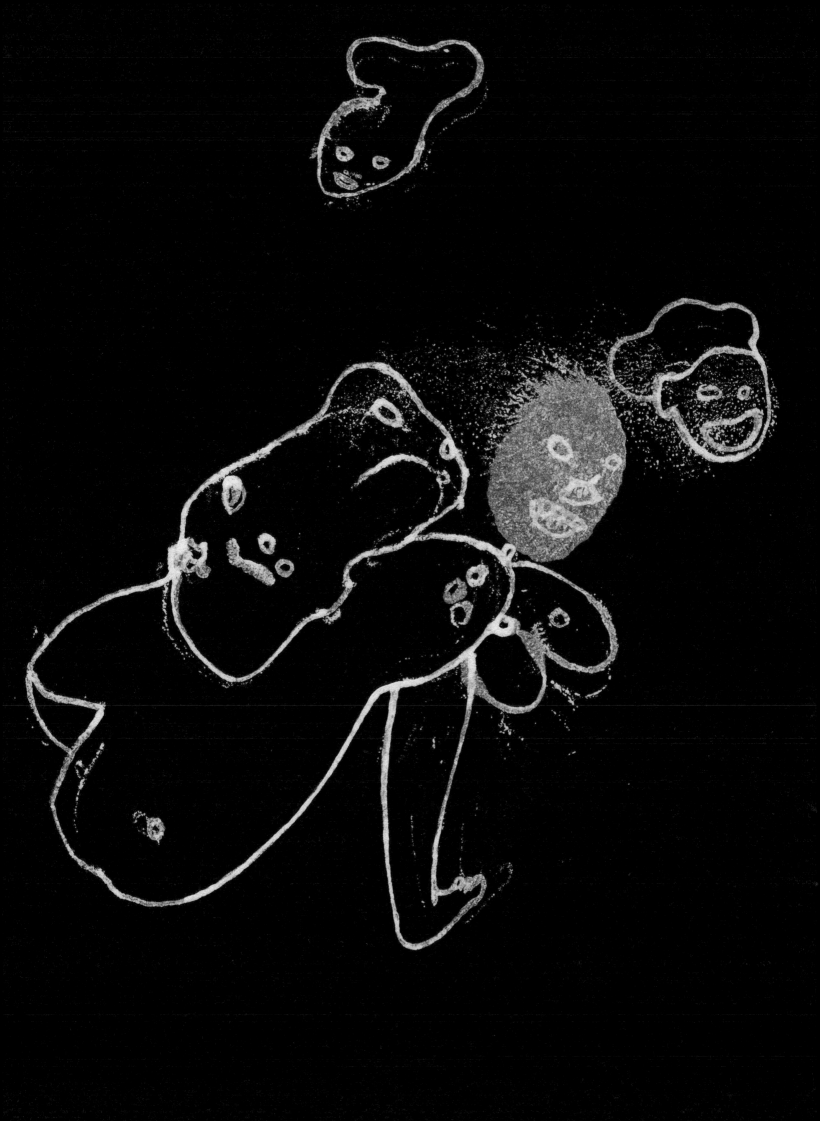

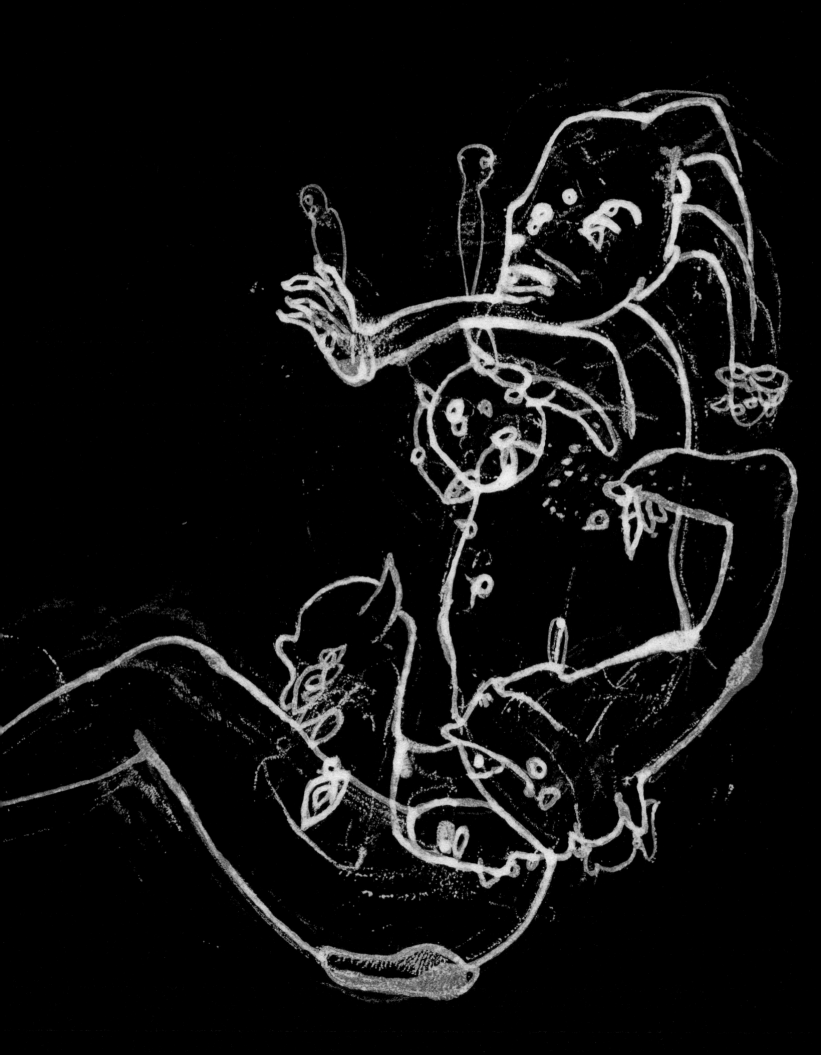

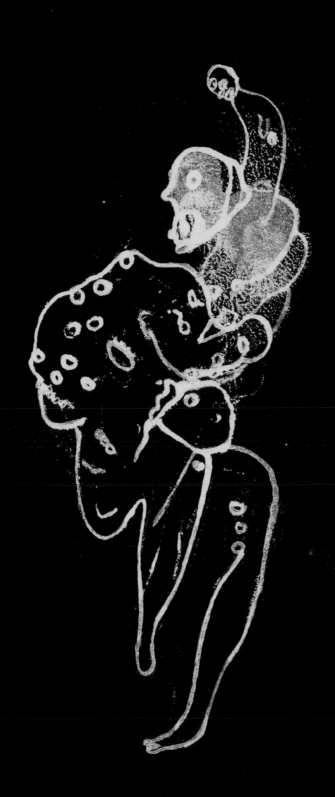

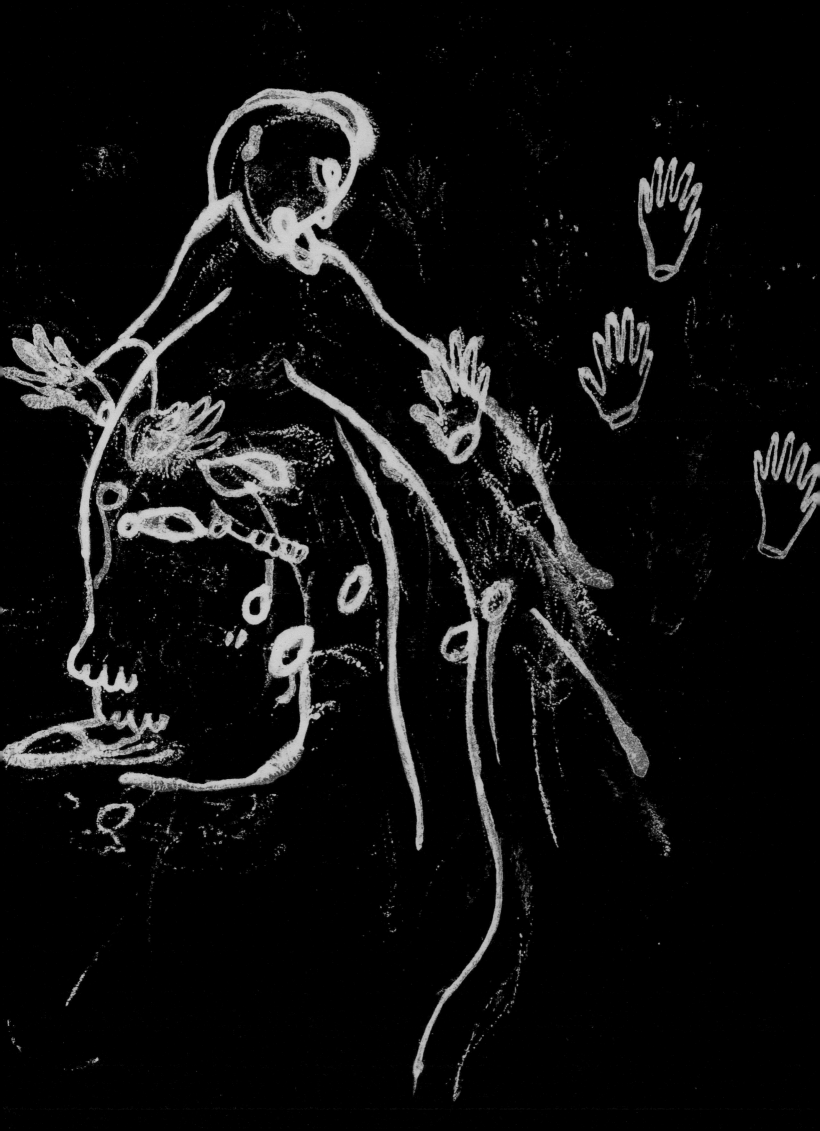

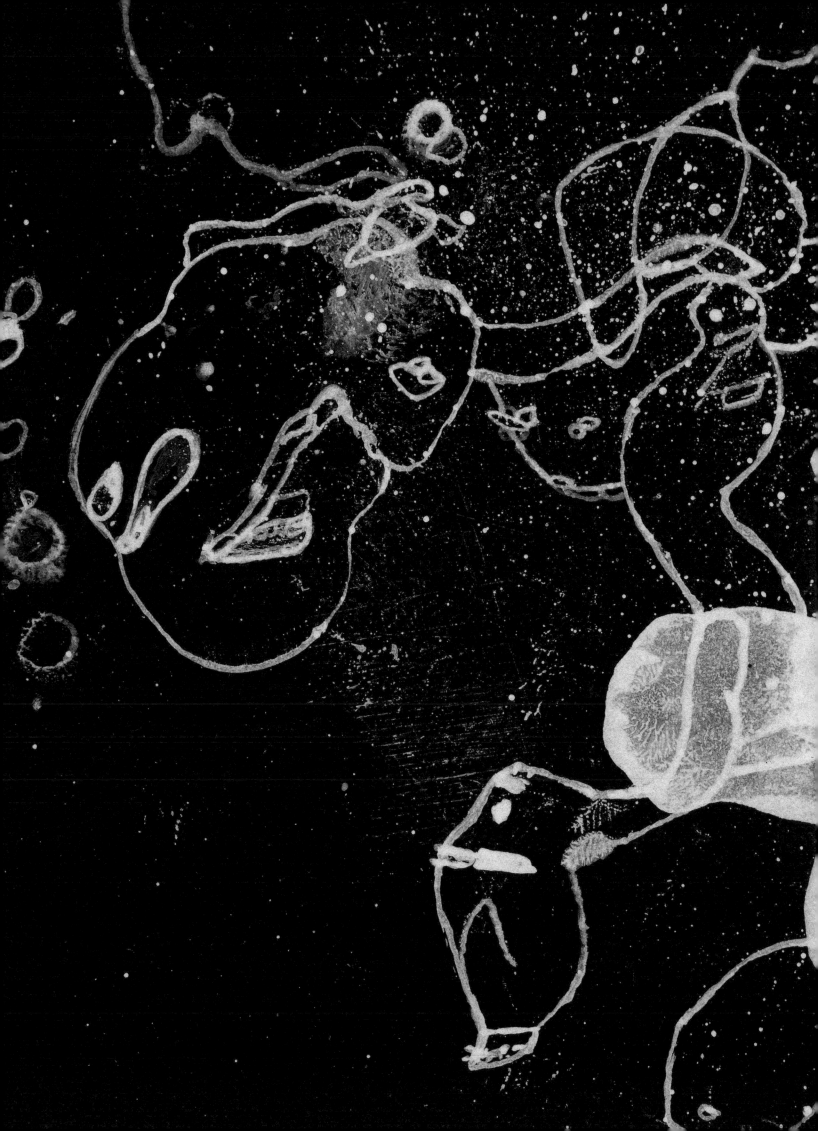

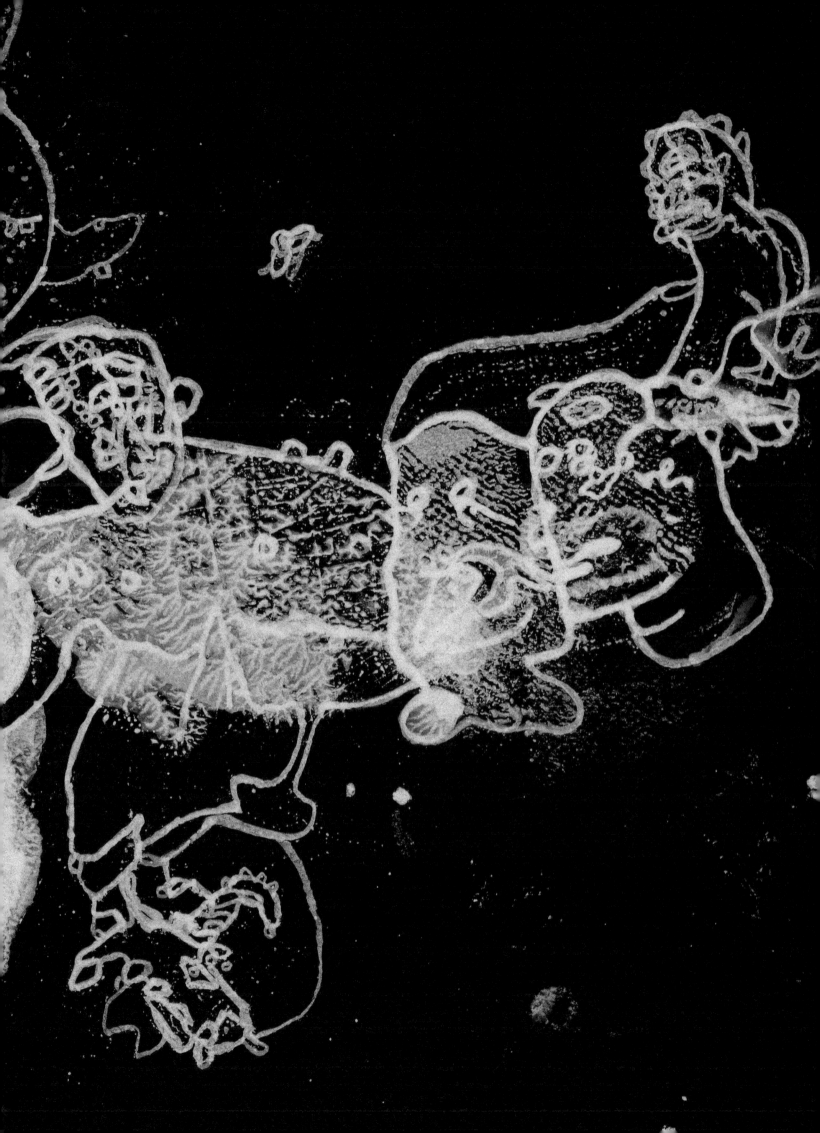

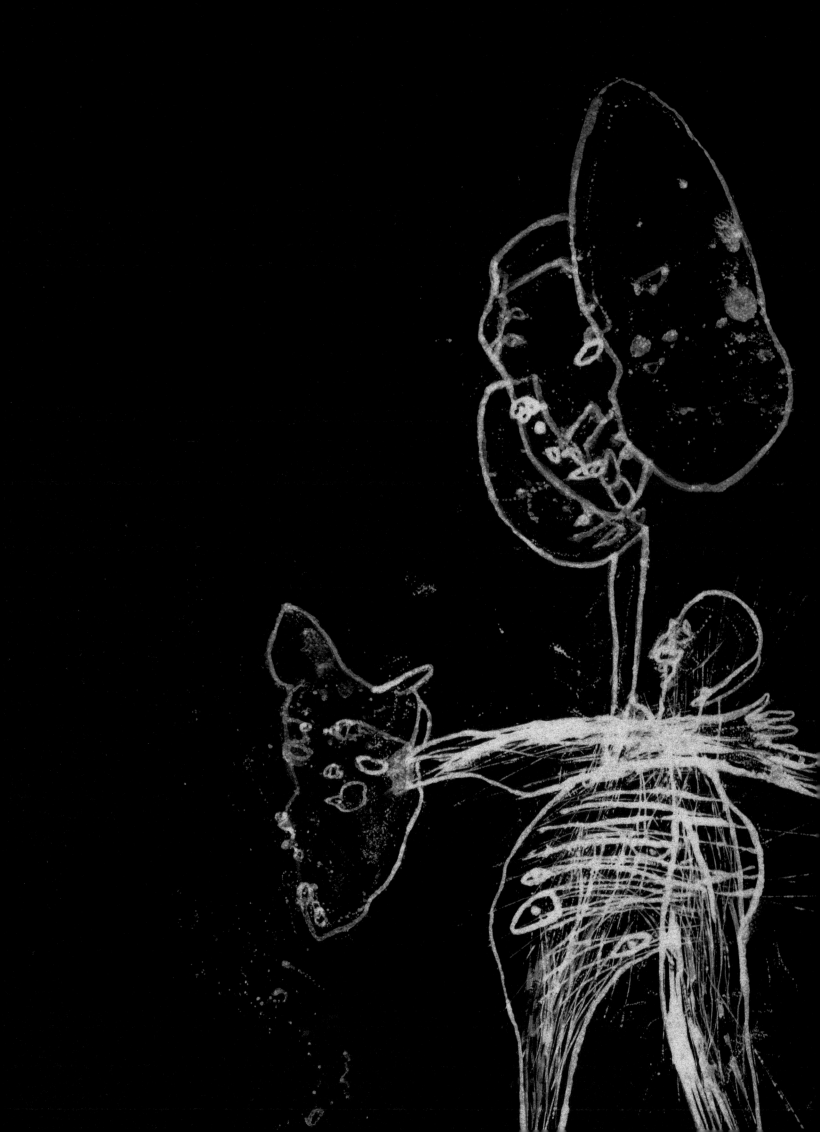

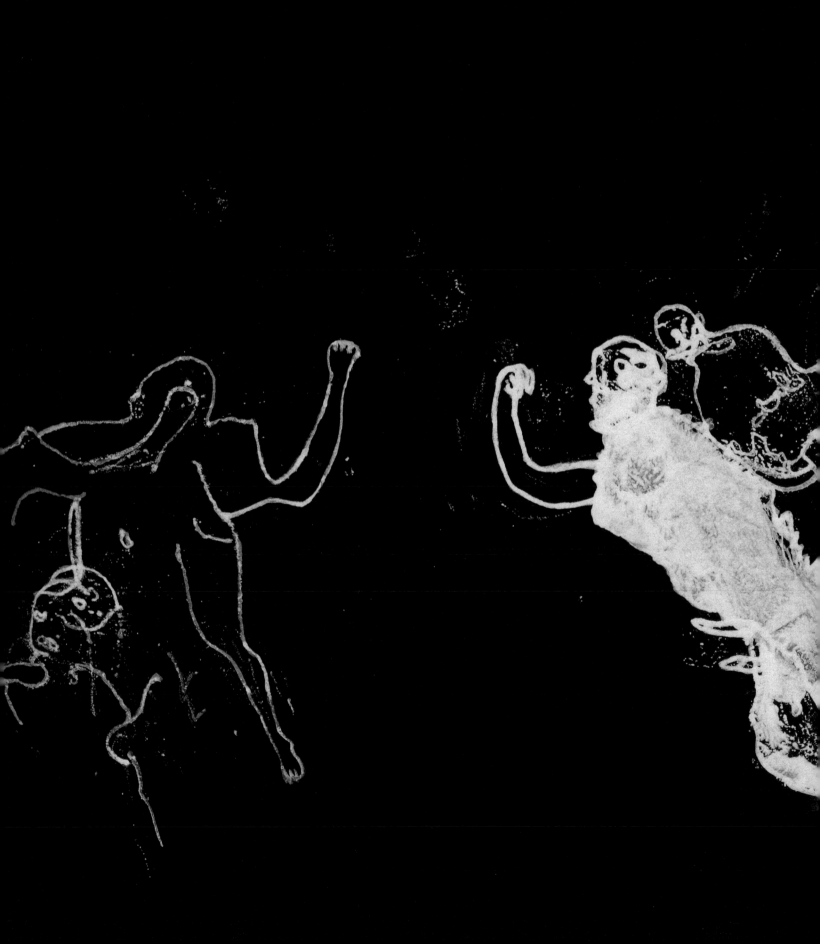

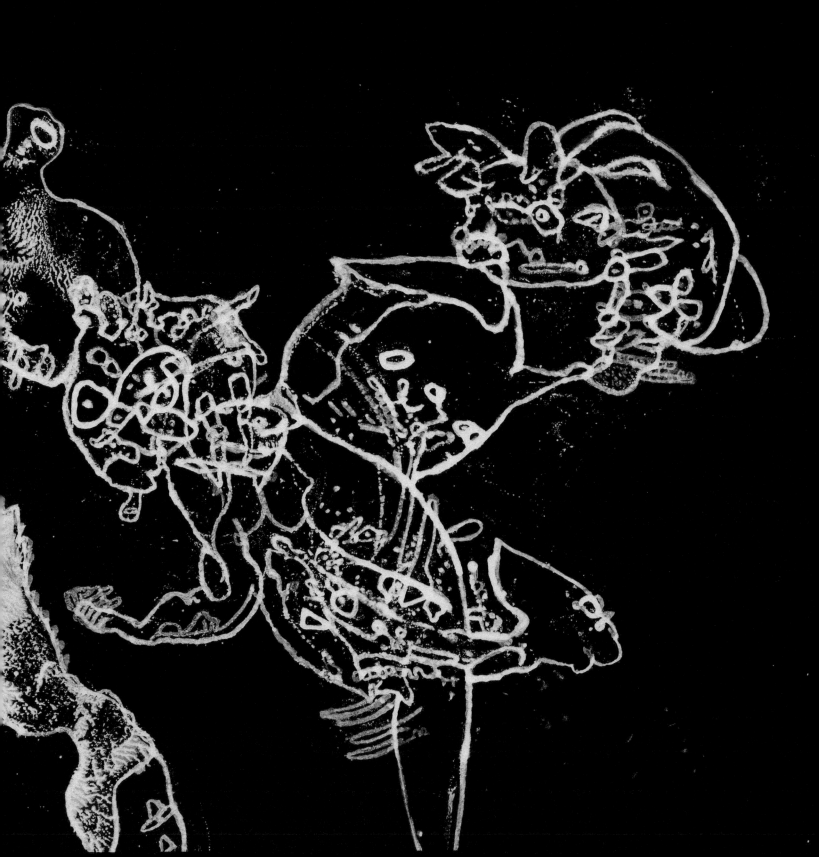

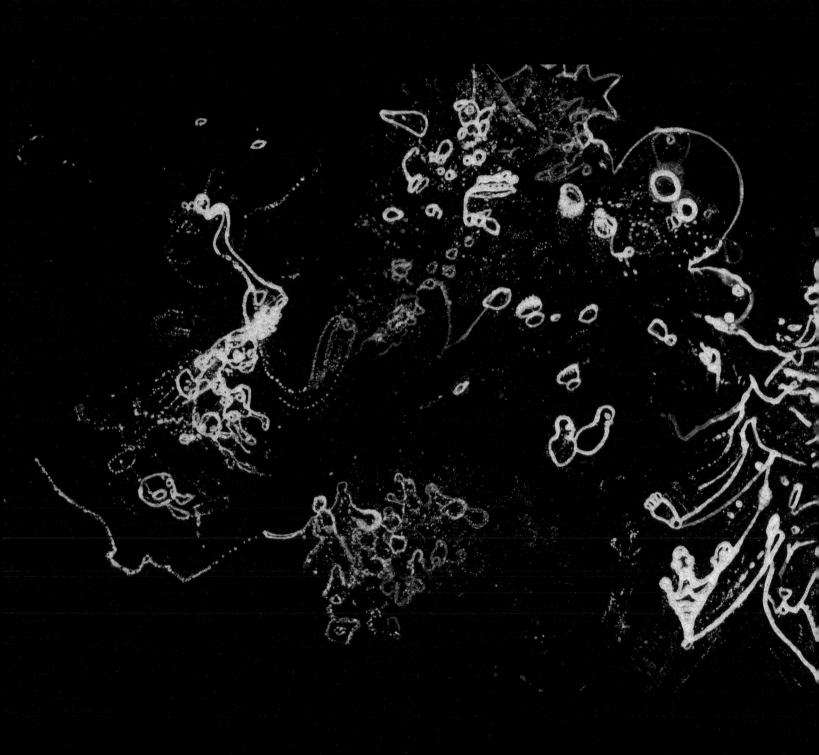

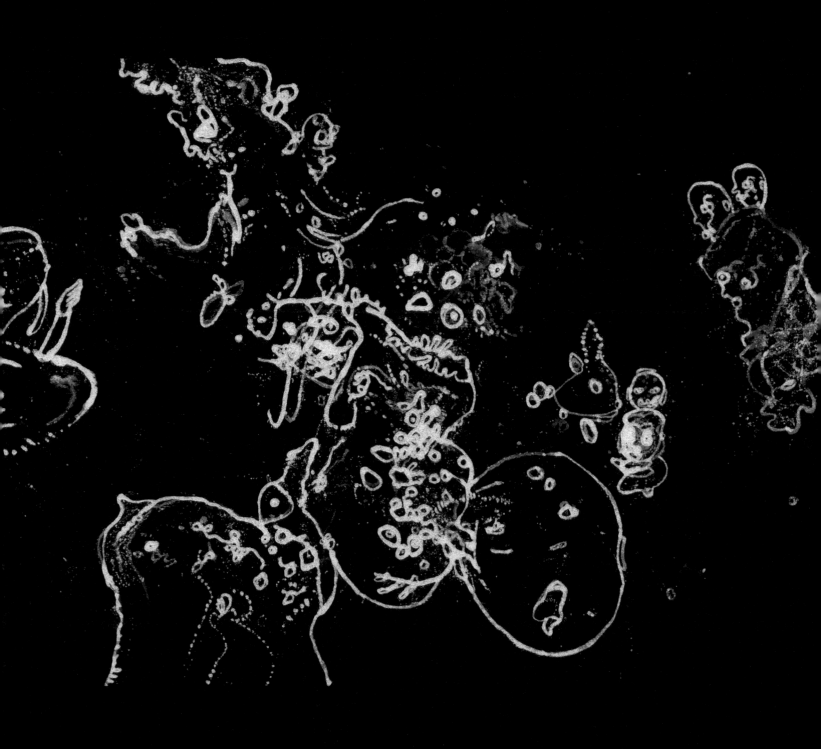

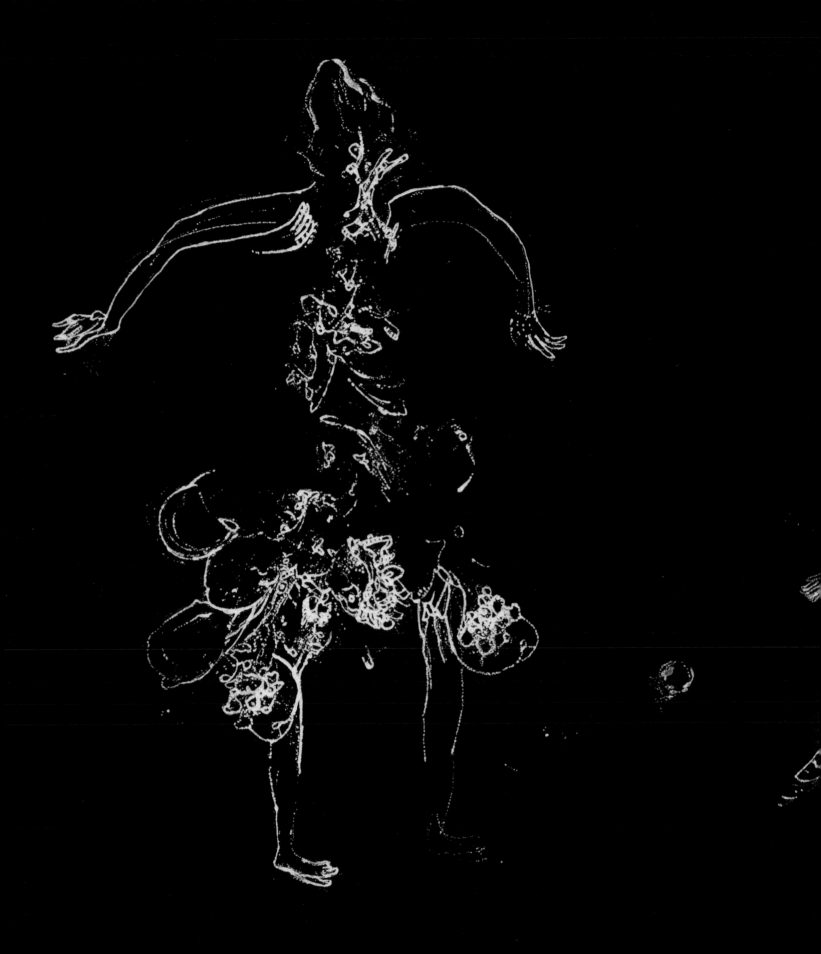

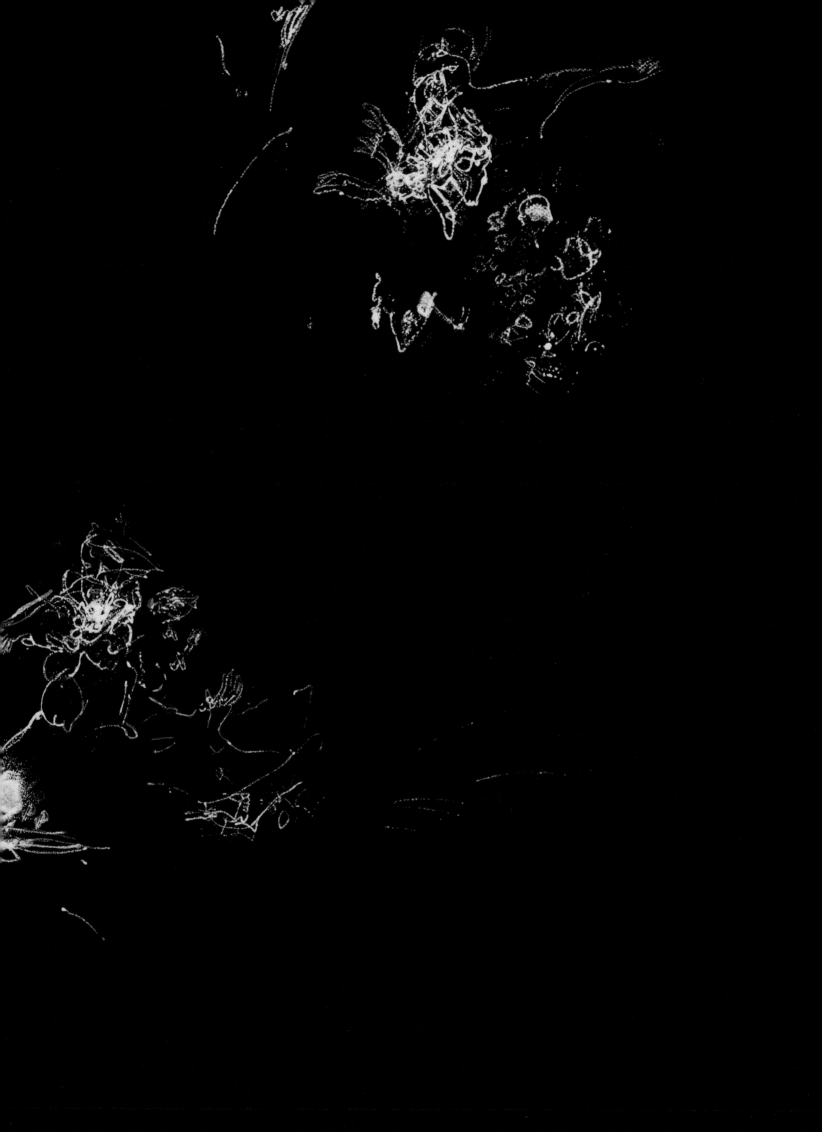

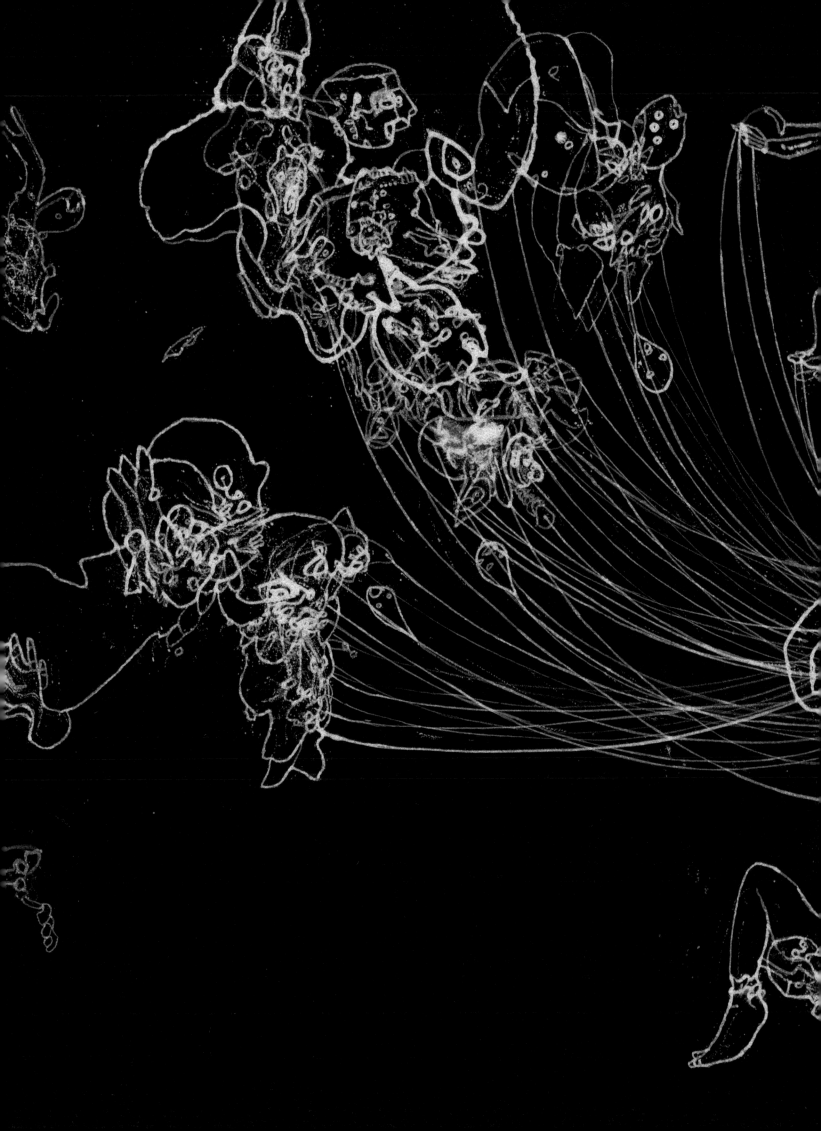

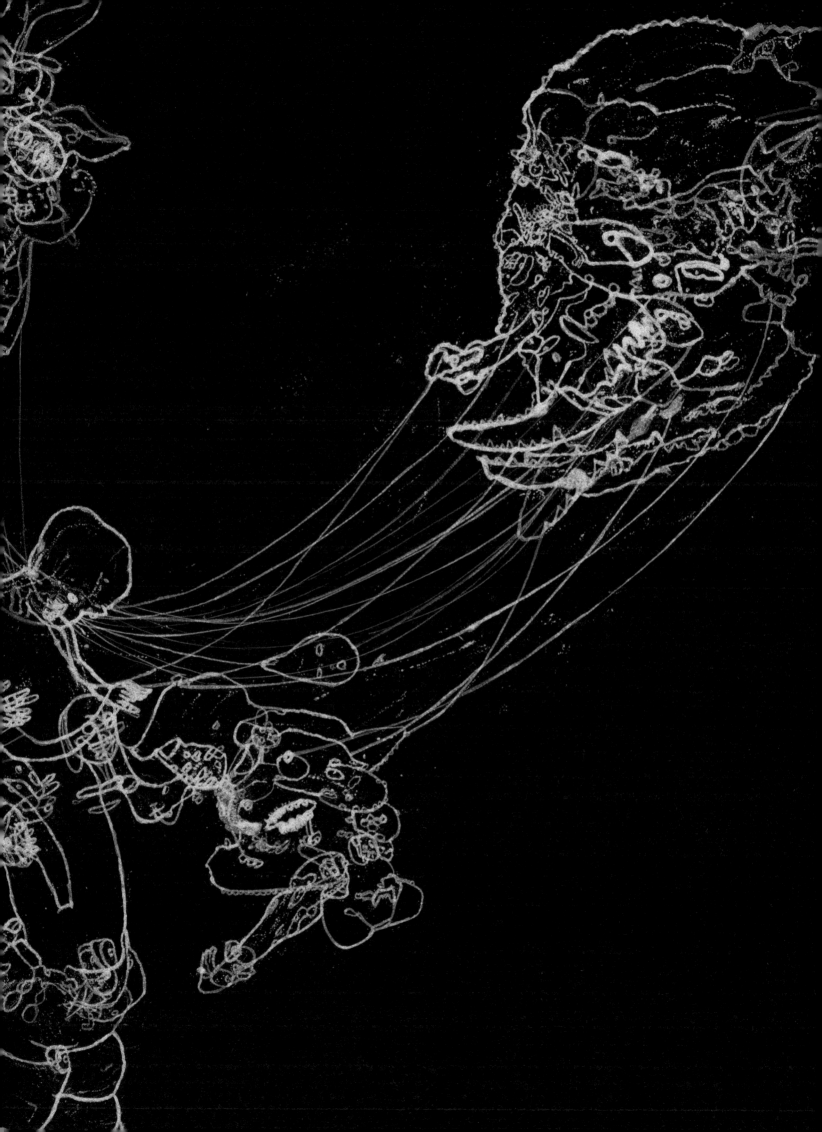

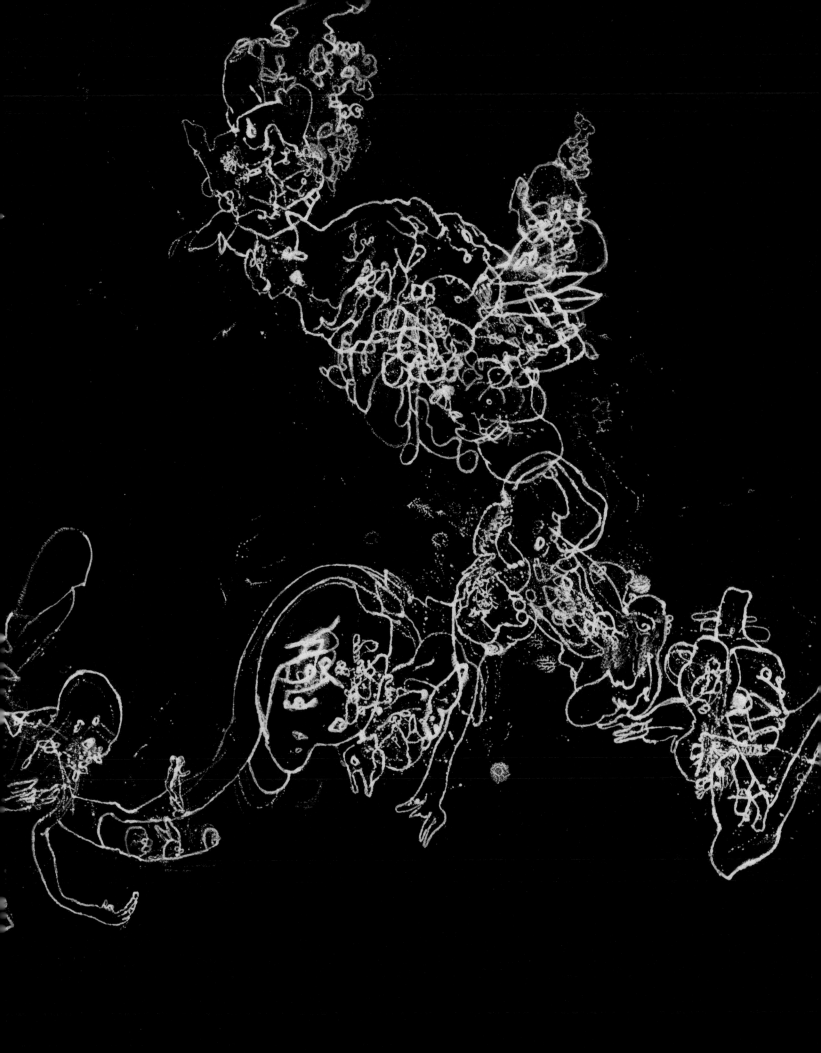

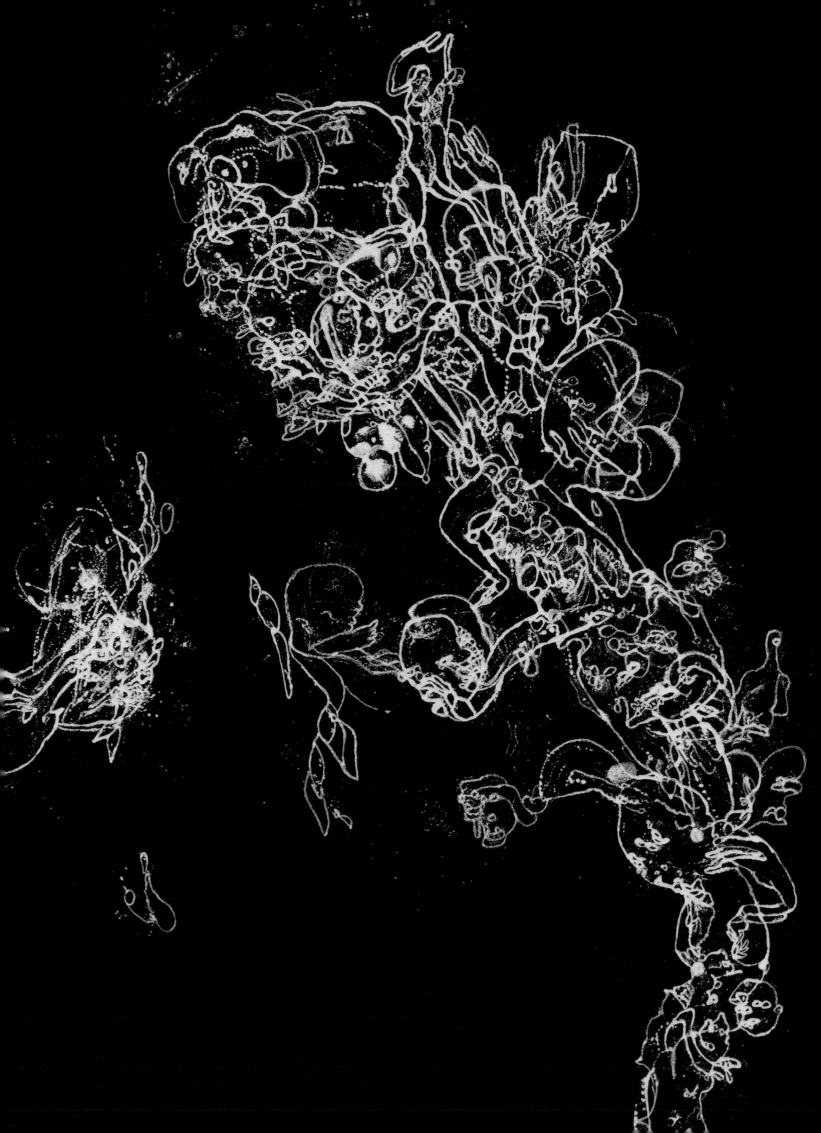

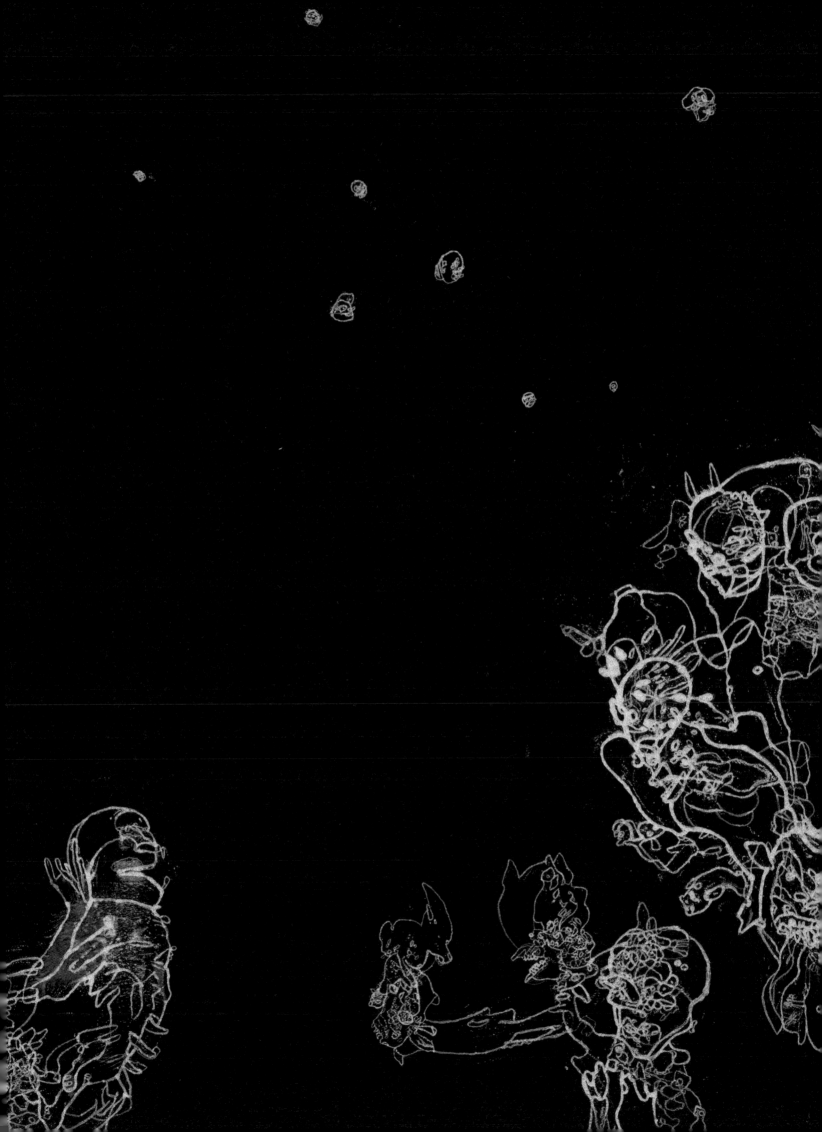

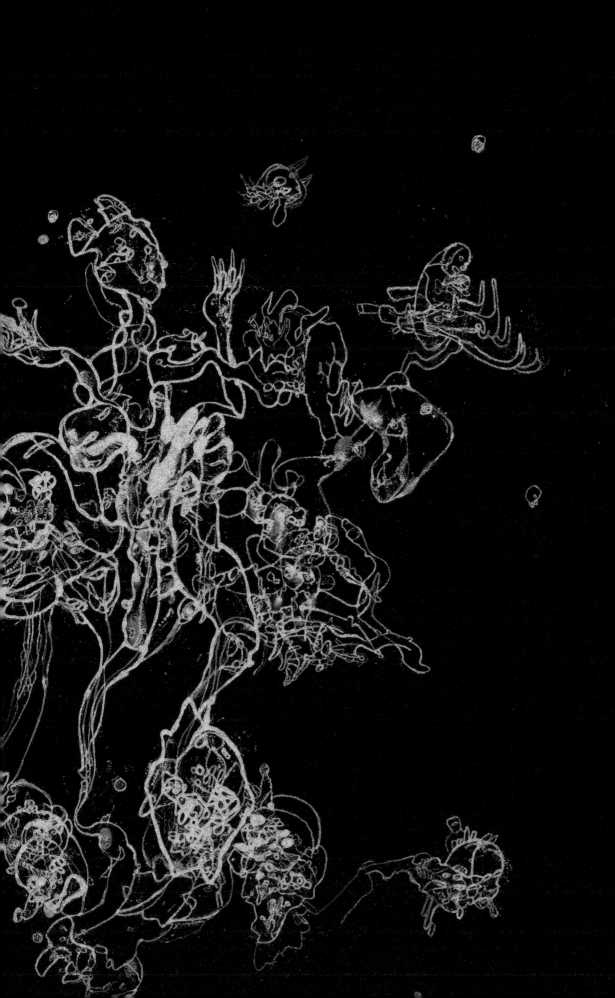

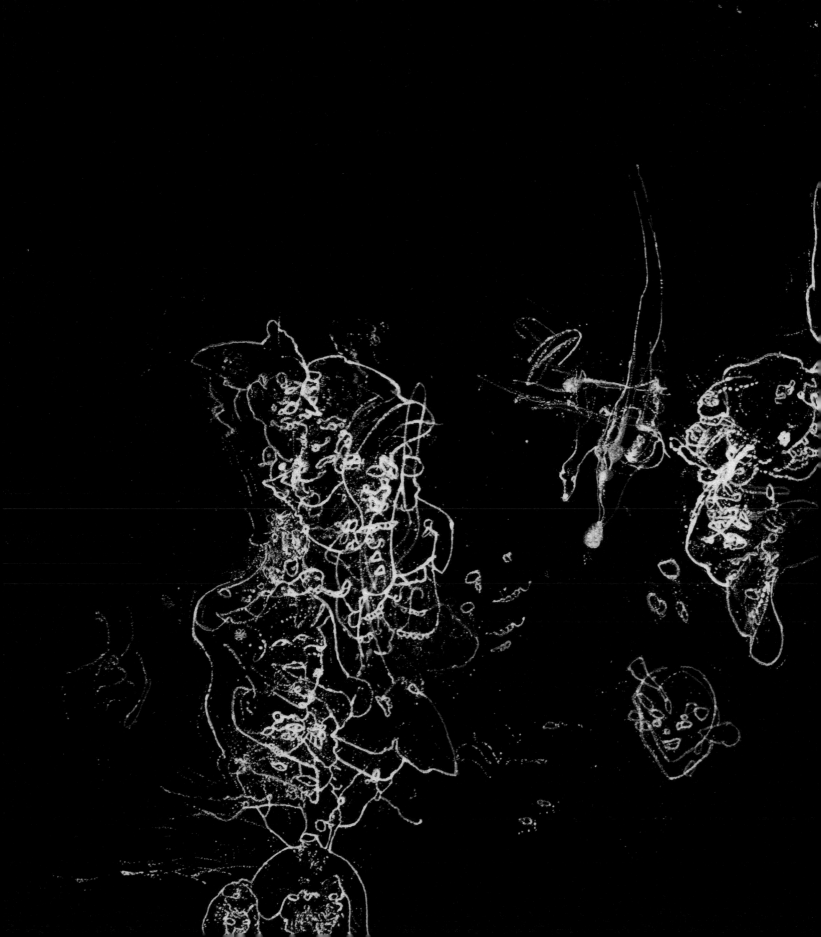

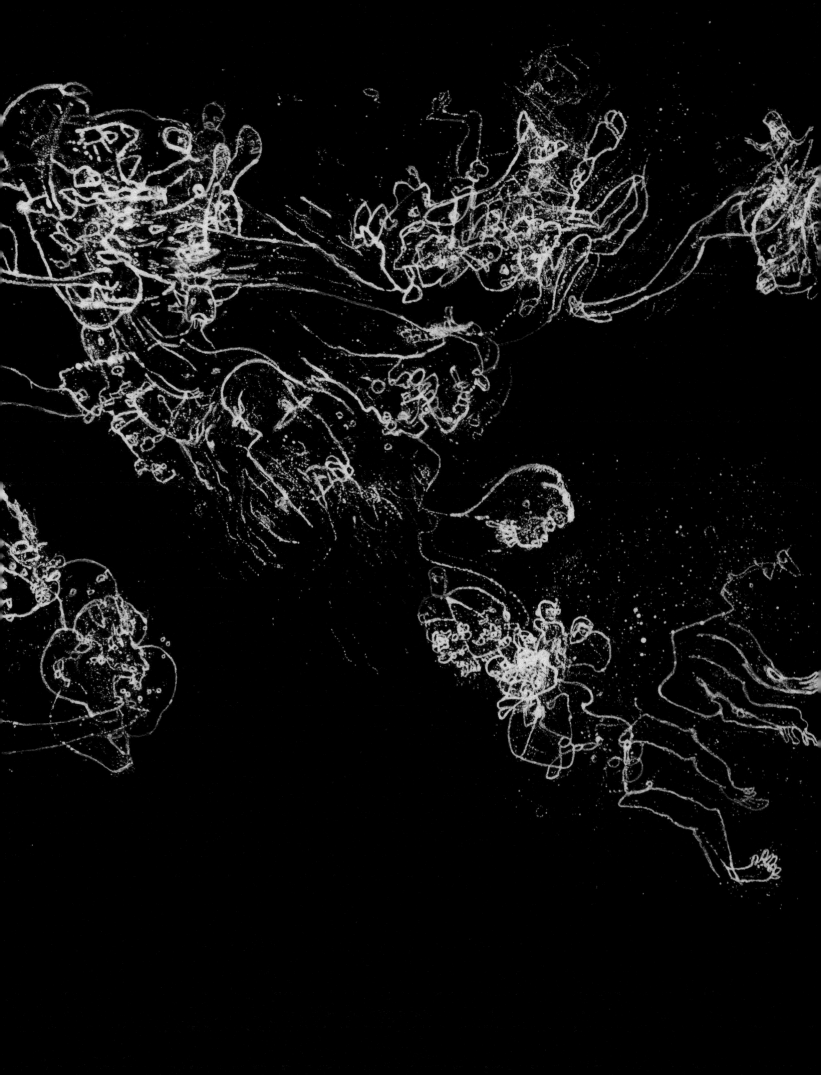

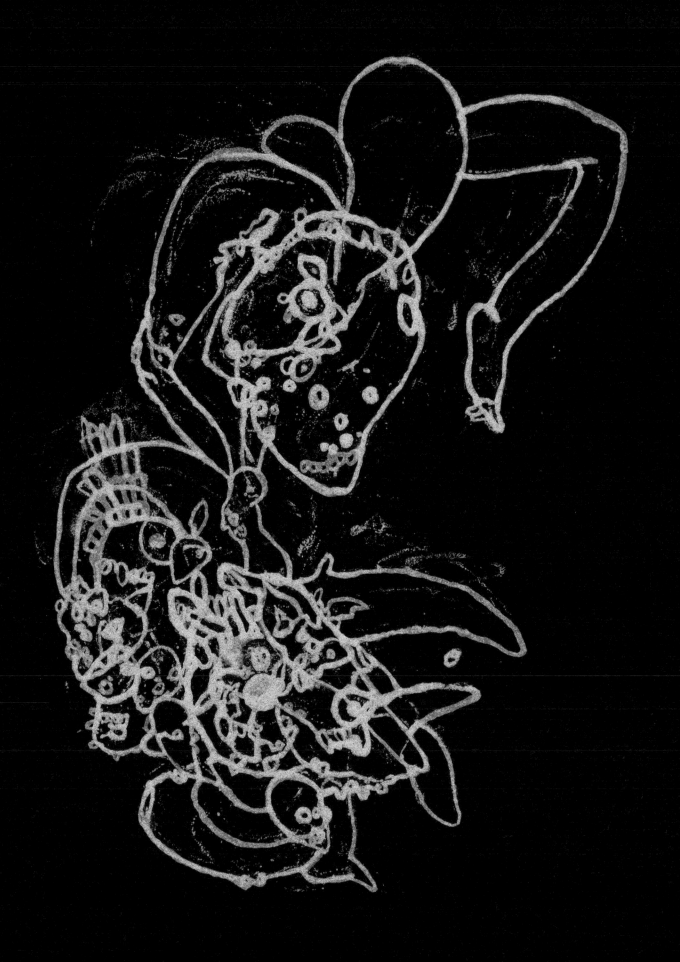

THE SPECTRAL DRAWINGS

In his final years, and to his surprise, psychologist CJ Jung found himself writing about "the interplay between the 'here' and the 'hereafter'"— namely, his experience of ghosts.[1] He explained: "… without my wishing and without my doing anything about it, thoughts of this nature move about within me".[2]

In a similar vein, Ed Pien has been compelled to draw ghosts, explaining that this came out of an interest in "concepts of fears and vulnerabilities".[3] He made his first ghost drawings in 1996, during a trip back to Taiwan, where he lived until he was 11. Using lurid green and dirt black ink he depicted the faces of hundreds of ghouls, inspired by local myths, newspaper images of human suffering and also his own imagination, together with the stirrings of his own childhood memories. About 15 years later, wanting to test out on himself the idea that "some of our fears are culturally engendered", he made his first visit to China, where his father was originally from.

> During my visit I asked people if they believed in ghosts. People responded as if reciting from some school text: 'there are no ghosts, gods nor demons'. Later, at an opening in Beijing, an artist said to me, the issue is not whether or not people believe in ghosts, the fact is, every Chinese person is afraid of ghosts. He hit it right on the nail. It is completely true. I fall into this very camp. Through the way we are brought up, our entire sense of existence is tied to this fear of ghosts.

My own research into ghosts in East Asia quickly opened up a wealth of tradition and custom. Each year, there is the month-long Hungry Ghost

Festival, in which lost spirits roam among the living, who try to appease these ghosts with such things as food offerings and entertainment. In addition, there are at least 17 categories of supernatural being in China, from the Ba jiao gui, the banana ghost who helps with lottery numbers, to the Zhong yin shen, a spirit in transition before reincarnation. Added to this we find a whole gamut of ghost stories, from the enduringly popular *Strange Tales from a Chinese Studio,* by seventeenth-century Pu Songling, to much-loved children's cartoons such as *Grandma and her Ghosts,* made in 2000.[4] Specific inspirations for Ed Pien include *Guigu tu* (the "Ghost Amusement scroll") by artist Luo Ping (1733–1799), depicting specters of many kinds that he claimed to have seen with his own eyes, and a breathtaking bestiary called *Guideways through Mountains and Seas,* compiled between the fourth and first centuries BCE.

Not long after returning from China, while thoughts of ghosts were once again (to paraphrase Jung) "moving about within him", Ed Pien spotted something that led to the creation of the drawings in this exhibition: "The *Spectral Drawings* began when I saw a bird dropping on a dark-coloured sidewalk. The mark reminded me of ectoplasm. The encounter inspired me to try using white ink on black paper."

The technique he used for these drawings was to daub ink onto areas of the paper, then make a print onto a second sheet, then back onto the first or perhaps onto a third, and so on. As part of the process, sheets were joined together, in twos, threes or more. Through the printing and pressing and shifting he created marks that were deliberately not quite his own—that drew him in, demanded something of him. Working lightly and rapidly, with his pen and brush he gave definition and character to the smudges, giving rise to myriad tiny phantasms, somewhere beyond the surface of his paper.

Look very closely and these ghosts will grimace, or stare back out at you. Floating in the darkness, many have coagulated into groups. The drawn white marks are in many places broken or less distinct, and so the phantasms appear to advance and recede, in and out of the gloom. In *Young Heir,* one ghost is borne aloft by a whole gaggle, while other ghosts turn and crane their necks towards this figure. At the same time, stray appendages, heads and eyes float and bob unawares, as if caught on a different current. In *The Captive,* swarms of specters and specter-fragments have attached gossamer strands to a desolate-looking ghost, which they

seem about to carry aloft or perhaps tear apart. *Lost Souls* is perhaps the most alien of all: body parts appear to gather into a jeering mass, while a second cluster, this time of heads with weeping eyes, is spreading and dissolving. Scrutinizing the specimen ghosts and ghost-parts, which look almost as if they are growing and multiplying like organisms on a Petri dish, I found myself wondering if Ed Pien's ghosts are specifically Chinese in character, or if he is channeling something more widespread.

It seems every part of the world, and every culture, every era, and every art form (high and lowbrow), has its ghosts. On the internet, there are accounts of present-day ghost sightings from each part of the globe. It is a vast subject, but a handful of examples from literature will quickly show us some of the contrasting ways in which ghosts are fashioned, and at the same time reveal that different ghost-types are neither specific to place, nor to period. And so—quite unlike Ed Pien's ghost-renderings—the dead can appear in broad daylight, looking very much as they did when they were alive, not only in many of Pu Songling's seventeenth-century Chinese stories but also in Columbian novelist Gabriel García Márquez's *One Hundred Years of Solitude,* written in 1967. Other sightings in Pu Songling's tales, however, are of ghosts that closely resemble the *Spectral Drawings* series—such as that of a man who saw, "during the night ghostly will-o'-the-wisp flickerings of light beneath his bed".[5] Another encounter in literature that could easily stand as a description of Ed Pien's ghosts, can be found in British-American Henry James' tale *The Turn of the Screw,* from 1898: "... the strange, dizzy lift or swim (I try for terms!) into a stillness, a pause of all life...".[6]

Darkness is often necessary for ghosts, and this and also the blackness of his paper were important to Ed Pien: "Some of the *Spectral Drawing* sessions took place in semi-dark settings. Under this condition, the black paper seems to lose its surface and becomes pure space or void that the images and marks hover in."

As much as darkness, writers often describe ghosts in terms of cold, or stillness, or absence, or silence—that is, other kinds of negative value. In Walter de la Mare's *The Listeners,* 1912, for example, the presence of ghosts is registered within a "silence [that] surged softly backward", in a poem in which a shushing "s" sound builds when read out loud.[7] I feel an equivalent kind of chill, imagining myself at the shoulder of Ed Pien as he draws, in the dark and quiet, the faintest susurration of brush on

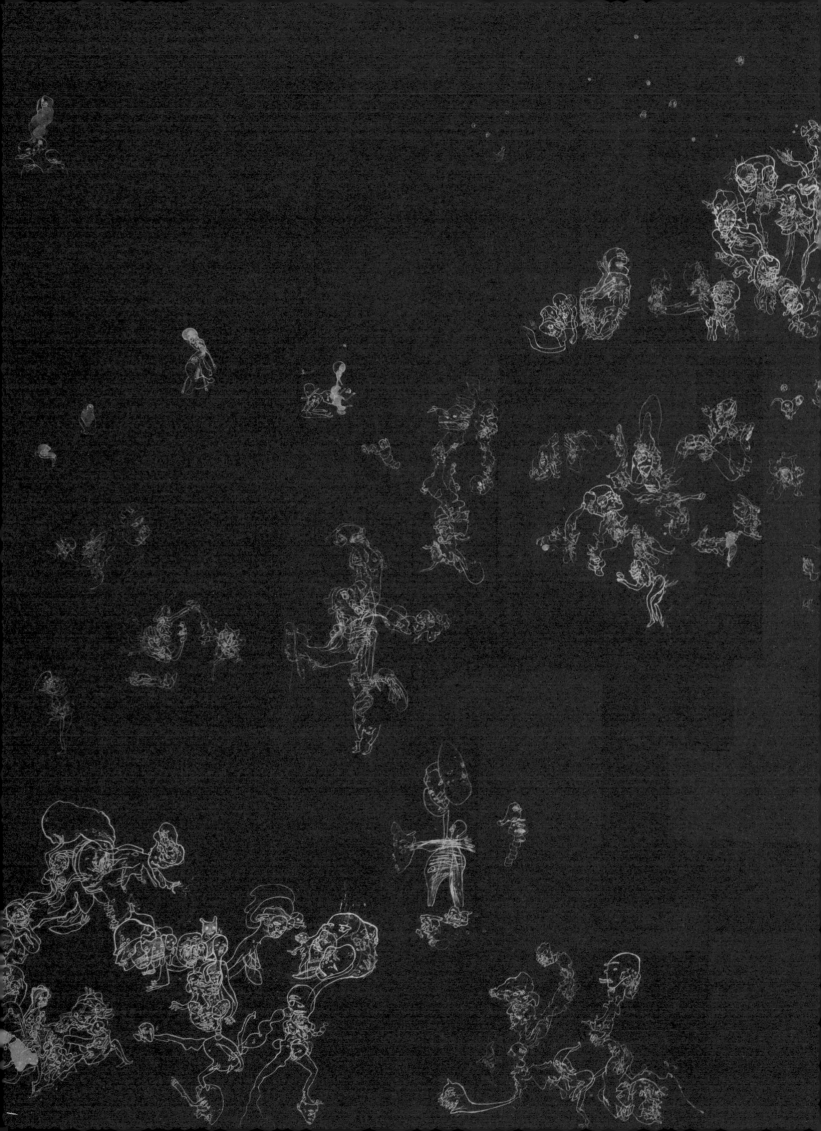

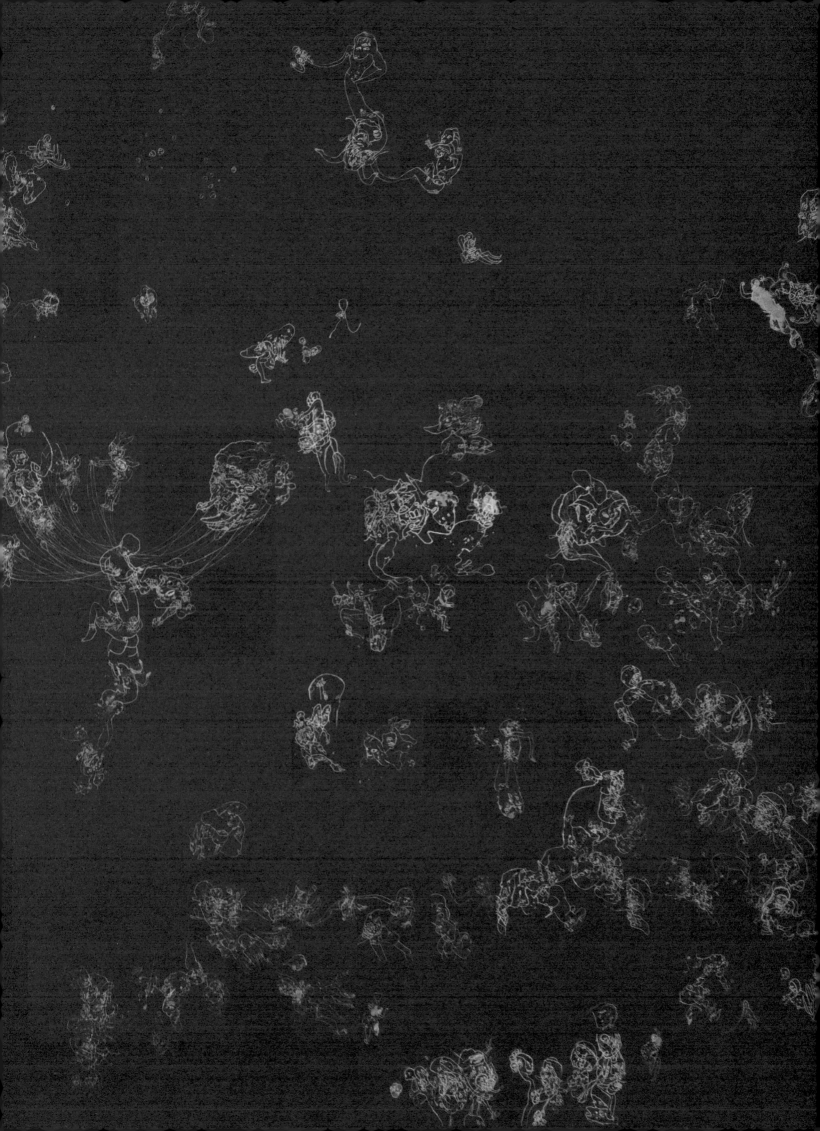

paper, reliant on senses other than sight. In his words: "... the drawing is as much about a haptic experience as it is an optical one. Actual contact between paper and brush informs me that a mark will materialize."

I am struck by the artist's use of the words "drawing sessions"–the French for session being *séance*. Indeed, Ed Pien conceives of himself as an intermediary between worlds: "I collaborate with what constitutes the ghostly", he says. His purpose is "to further my exploration of otherness, difference, empathy, negotiation and conciliation". For him, the ghost-world, utterly disquieting and strange, is nevertheless charged with potential, as an "other-valued reality" within which new ways of thinking and being and connecting might become possible.[8] Take ghosts as fantasy or metaphor if you will–the main point being that, if we are to change the status quo and its many constraints, psychological risks will need to be taken. For, deep within the dark folds of this deathly realm, there is a resonance and a freedom, delicately intuited in *The Turn of the Screw* in this pulsating phrase: "Nothing was more natural than that these things should be the other things they absolutely were not."[9]

Pursuing this kind of double negative himself, Ed Pien states: "I also see ghosts as this Other Other, if that makes any sense." He cites an interest in the literary theorist Edward Said, who was concerned with the corrosive effects of the positioning by Western imperialists of the Eastern world as Oriental and thereby Other–an Other that has functioned as a kind of false opposite in the creation of the self-identity of the West.[10] In this vein, the artist continues: "I am interested in the idea of haunting, not just in the ghostly sense but how a condition is set up in the past that comes back to haunt us."

So what *are* ghosts? Lost spirits, unfinished business, residues of sadness or anger; for intellect-hungry Jung they were the dead "endeavour[ing] to penetrate into life in order to share in the knowledge of men".[11] On the other hand, Ed Pien's conjecturing of ghosts as a kind of fallout from the past extends also into the experience of the individual. His innovation is that they co-exist with us as a form of conscience while we are still alive: "we become our own ghost that comes back to haunt ourselves, depending on the conditions we have created in the past and present". Ghosts of the past and present hauntings: Ed Pien ventures into a dark arena where new relations might become imaginable.

1 Jung, CJ, *Memories, Dreams, Reflections,* 1963, Richard and Clara
 Winston trans, London: Fontana, p 330.

2 Jung, CJ, *Memories, Dreams, Reflections,* p 330.

3 All quotations by the artist in this essay are from email exchanges,
 summer 2015.

4 I am grateful to Li Jiaxu and Dan Hanyin for their invaluable help here.

5 Pu, Songling, *Strange Stories from a Chinese Studio,* John Minford trans,
 Penguin Classics: London, 2006, p 104. First published in 1740.

6 Ghost stories are probably much like fairy tales, which cannot be pinned
 to a place or time: for example, as Angela Carter describes, *Cinderella*
 originated as much in China as Northern England, was most likely
 spread through the trade routes, and is continuously recreated for each
 generation. See, Carter, Angela, "Introduction", *The Virago Book of Fairy
 Tales,* 1990; also discussed in Kingston, Angela, "Lost in the Woods",
 The House in the Woods, Glasgow: CCA, 1998.

7 de la Mare, Walter, "The Listeners", 1912. See www.poetryfoundation.
 org/poem/177007

8 The phrase is from Jung, *Memories, Dreams, Reflections*, p 336.

9 James, Henry, *The Turn of the Screw,* Wordsworth Editions: Ware,
 Hertfordshire, UK, 2000, p 32. First published in 1898.

10 Said, Edward W, *Orientalism: Western Conceptions of the Orient,* Penguin:
 London, 1995. First published in 1978.

11 Jung, *Memories, Dreams, Reflections*, p 339.

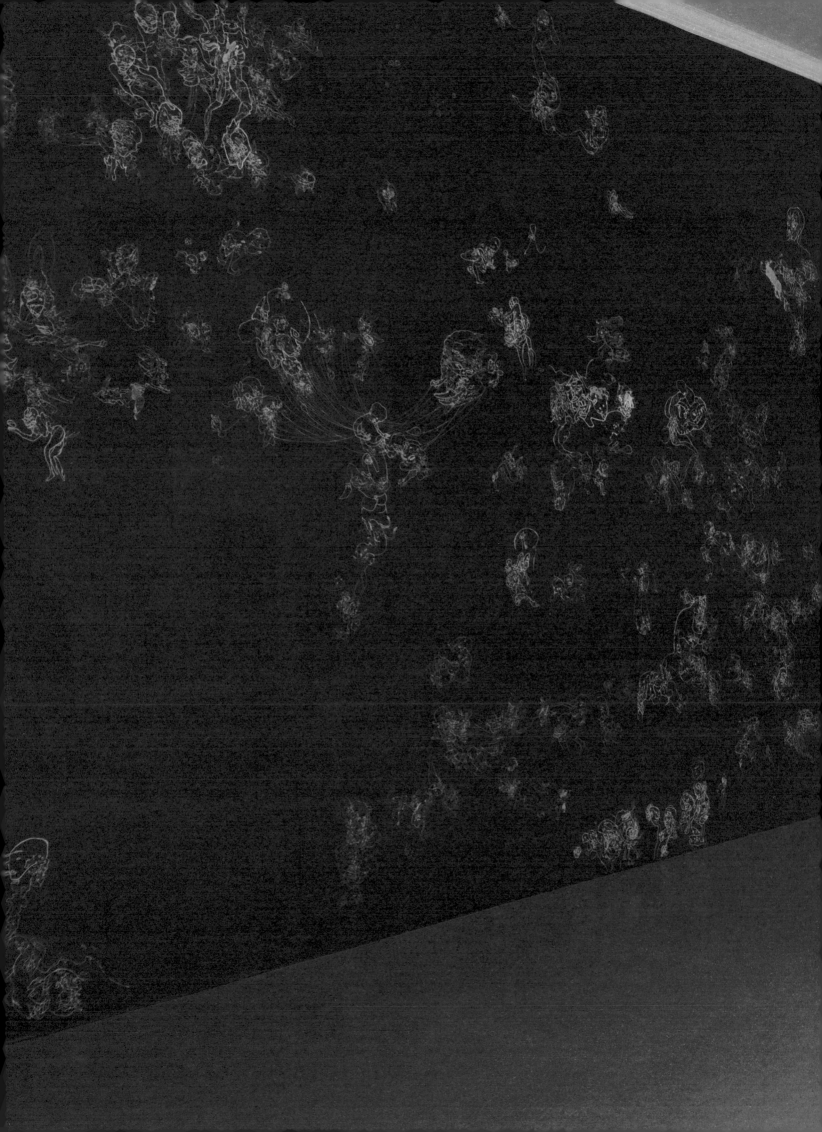

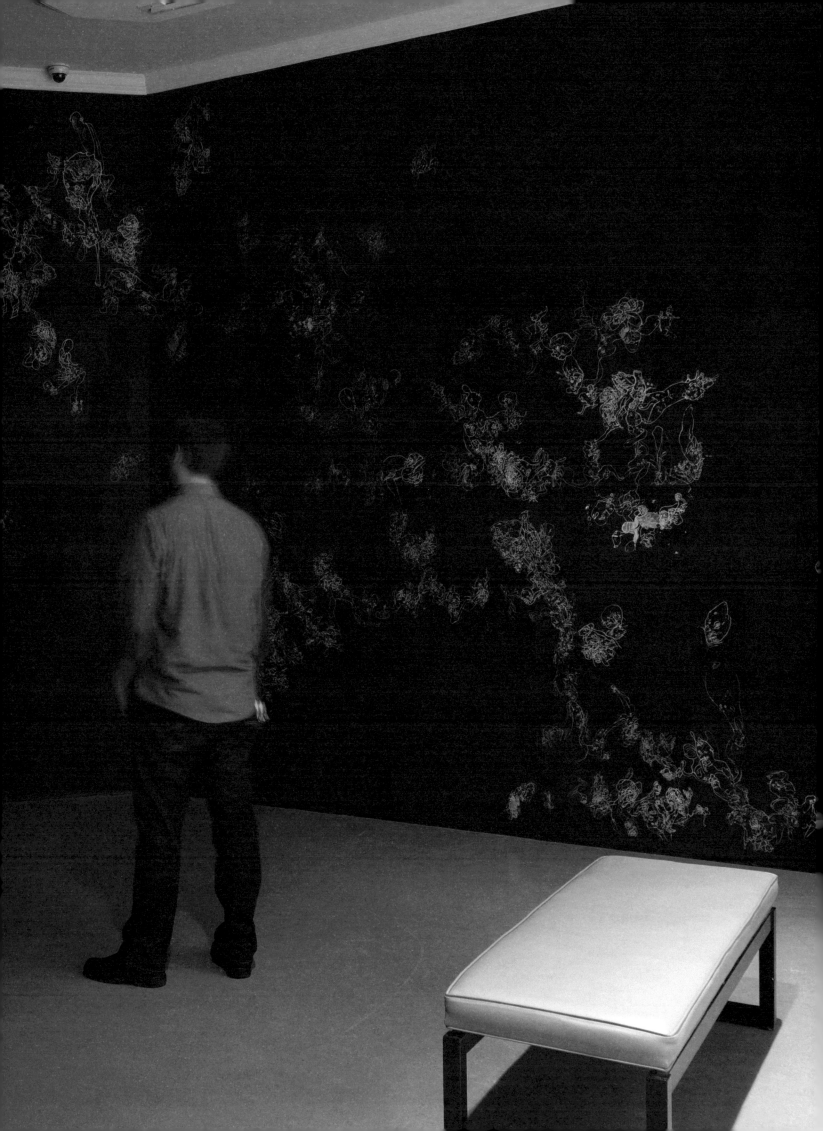

LIST OF WORKS

p 4
Imaginary Dwelling,
2012–2015
clear mylar, fabric, sound and video
5.18 x 3.96 m

p 8
For All the Tea in China, 1999
ink on paper, PVC pipes and wood
3 x 2.13 m

p 11
The Promise of Solitude
(details), 2005
ink, Shoji paper, thread, wood, PVC pipes
3.96 x 6.1 x 6.1 m
Photograph by Didier Morel
Courtesy of Wharf, Lower Normandy
Contemporary Art Centre, 2005

p 12
Two Worlds: Liquid Being 4, 1999
ink, Flashe and acrylic on paper
21.6 x 27.9 cm

p 14
Two Worlds: Girl, 1999
ink, Flashe and acrylic on paper
21.6 x 27.9 cm

p 15
Two Worlds: Kneeling Boy, 1999
ink, Flashe and acrylic on paper
21.6 x 27.9 cm

pp 16–17
Ghosts, 1998
ink on Japanese silk paper
and tracing paper, light, motion
sensor and ceiling fan
variable dimensions
Photograph by Denis Farley

pp 18–19
Drawing on Hell, Paris,
1999–2004
ink and Flashe on paper
2.79 x 4.12 m
Photograph by Ton Hafkenscheid

p 20
In a Realm of Others, 2001
ink, glassine, PVC pipes, sound, video
projection, TV monitor
12.3 x 5.54 x 4 m
Photograph by Don Gill
Courtesy of the Southern
Alberta Art Gallery.

p 22
Tracing Night, 2004
ink on glassine, PVC pipes,
sound and video projection
13.7 x 5.5 x 3.71 m
Photograph by Steven Farmer

p 24
Haven, 2007
paper, ink, sound, video,
overhead projection and light
variable dimensions
Photograph by Richard-Max Tremblay

p 25
Une nuit de lunes, 2008
wood, paper, stones, foam, fabric,
mirrors, sound and video projection
variable dimensions
Photograph by David Barbour

pp 26–27
Memento, 2009
rope, sand bags, mirrors, glassine,
Tyvek, sound and video projections
variable dimensions
Photograph by Toni Hafkenscheid
Courtesy of Storey Gallery, Lancaster,
England. Commissioned by the
Chinese Centre for Contemporary
Art (formerly named The Chinese
Arts Centre), Manchester

p 29
Grand Thieves (detail), 1999–2010
ink and Flashe on panelled paper
3.48 x 1.97 m
Photograph by Toni Hafkenscheid

pp 31, 34–35
Ad Infinitum (detail), 1999–2010
ink and Flashe on panelled paper
3.92 x 1.97 m
Photograph by Toni Hafkenscheid

pp 36–37
Ad Infinitum
(installation view), 1999–2010
ink and Flashe on panelled paper
3.92 x 1.97 m
Photograph by Toni Hafkenscheid

pp 40–41, 44
Source, 2012
video projection, sound by Tanya Tagaq
paper, Tyvek, clear mylar, rope
variable dimensions
Photograph by William Newell

IMAGINARY
DWELLING

pp 52–63 and 110–111
Imaginary Dwelling, 2012–2015
clear mylar, fabric, sound and video
5.18 x 3.96 m

THE SPECTRAL
DRAWINGS

p 66
Fated, 2015
30.5 x 22.9 cm

p 67
Snatching Her Own, 2015
30.5 x 22.9 cm

p 68
Safety in Darkness, 2015
30.5 x 22.9 cm

p 69
Left For Dead, 2015
30.5 x 22.9 cm

p 70
Outsiders, 2015
30.5 x 22.9 cm

p 71
Recrossing the Rubicon, 2015
30.5 x 22.9 cm

p 72
Blinding, Blistering, 2015
30.5 x 22.9 cm

p 73
Down to the Bones, 2015
30.5 x 22.9 cm

p 74
The Laughing Witch, 2015
30.5 x 22.9 cm

p 75
Plague Encircling, 2015
30.5 x 22.9 cm

p 76
Unseeing Witnesses, 2015
30.5 x 22.9 cm

p 77
Impending Retribution, 2015
30.5 x 22.9 cm

pp 78–79
Ashes and Dust, 2015
30.5 x 45.7 cm

pp 80–81
The Sorceress, 2015
61 x 45.7 cm

pp 82–83
Cast into Limbo, 2015
30.5 x 68.6 cm

pp 84–85
Under its Spell, 2015
30.5 x 91.4 cm

pp 86–87
Hex, 2010
76.2 x 114.3 cm

pp 88–89
The Captive, 2013
76.2 x 114.3 cm

pp 90–91
The Giant Ogre, 2011
76.2 x 114.3 cm

pp 92–93
Dispersing Souls, 2014
106.7 x 137.2 cm

pp 94–95
The Witching Hour, 2010
76.2 x 114.3 cm

p 96
Witnessing the Unspeakable, 2015
30.5 x 22.9 cm

pp 100–101 and 104–105
The Spectral Drawings
(installation view), 2015
white ink on panelled black paper
variable dimensions

List of Works

ED PIEN

When he was 11 years old, Ed Pien and his family emigrated from Taiwan to London, Ontario, where he would receive a BFA from Western University. He then moved to Toronto, where he continues to live, to do his MFA at York University. Pien has exhibited extensively, including shows at The Drawing Center, New York; La Biennale de Montréal; W139, Amsterdam; Contemporary Art Gallery, Vancouver; Middlesbrough Art Gallery, UK (now called Middlesbrough Institute of Modern Art); Centro Nacional de las Artes, Mexico City; Museo de Arte Contemporáneo de Monterrey, Mexico; Goethe-Institut, Berlin; Bluecoat, Liverpool, UK; the Art Gallery of Ontario, Toronto; and the National Gallery of Canada, Ottawa. In 2012 he participated in Oh Canada: Contemporary Art from North America, organized by the Massachusetts Museum of Contemporary Art, North Adams, MA. And in 2013, he presented *Imaginary Dwelling* for the first time at the 5th Moscow Biennale.

Pien currently teaches at University of Toronto. He is represented by Birch Contemporary, Toronto; Pierre-François Ouellette art contemporain, Montreal; and Galerie Maurits van de Laar in The Hague, The Netherlands.

www.edpien.com

CATHERINE DE ZEGHER

Catherine de Zegher is Director of the Museum of Fine Arts, Ghent, Belgium, and Member of the Royal Academy of Belgium of Science and the Arts. In 2013, she curated the 5th Moscow Biennale, Russia, and the Australian Pavilion at the 55th Venice Biennale, presenting the work of Simryn Gill. From 2010–2012, she was the Artistic Director of the 18th Biennale of Sydney, Australia. As Guest Curator in the Department of Drawings at the Museum of Modern Art in New York, 2009–2011, she organized the exhibition On Line. Drawing Through the Twentieth Century. In 2010, she was Visiting

Curator at the Tàpies Foundation in Barcelona. From 2007–2009, de Zegher was the Director of Exhibitions and Publications at the Art Gallery of Ontario in Toronto, and previous to this position, she was the Executive Director and Chief Curator of The Drawing Center in New York from 1999–2006. In the last 15 years, de Zegher has received several Best Show awards from AICA and AAMC. Author and editor of numerous books, recent publications include *Women Artists at the Millennium* from October Books, co-edited with Carol Armstrong, *all our relations* for the 18th Biennale of Sydney in 2012, and *More Light* for the 5th Moscow Biennale in 2013. Most recently, in 2014, de Zegher published *Women's Work Is Never Done*, an anthology of her collected essays on the work of contemporary women artists.

ANGELA KINGSTON

Angela Kingston is a freelance curator and writer based in London, UK. She has a strong interest in drawing and also in contemporary art that is otherworldly and fantastical. Drawings by Ed Pien have featured in two of her UK touring exhibitions: Underwater, a 10-artist exhibition about total submersion, which included drawings of mermen and sea monsters by Ed Pien, alongside works by Dorothy Cross, Ellen Gallagher, Bill Viola, etc, which was commissioned and toured by Towner, Eastbourne, 2010–2011; and 3am, a 22-artist show about the absolute depths of the night, with a selection of Ed Pien's *Spectral Drawings*, and also including works by, for example, Francis Alys, Sandra Cinto and Fred Tomaselli, which was commissioned and toured by the Bluecoat, Liverpool, 2013–2014.

www.angelakingston.co.uk

ARTIST'S ACKNOWLEDGEMENTS

Many individuals contributed to the creation
of the work exhibited in Luminous Shadows.
The artist thanks:

Johannes Zits (video editor)
Phil Baljeu (sound)
Isabel Boate, Naulaq Michael and
 her grandchild (video participants)
Shuvinai Ashoona
Heidrun Gabel-Koepff
 (studio assistant and tent maker)
Kaj Marshall, Jenny Pham, Andrew Rutherdale,
 Nicole Volgelzang, Atleigh Homma and
 Holly Timpener (studio assistants)
Pat Feheley
Pamela Meredith
 (Senior Art Curator, TD Bank Group)
Scott Mullin (Vice President, Community
 Relations, TD Bank Group)
TD Bank Group
Bill Ritchie
West Baffin/ Kinngait Co-operative
 artists and printmakers
Students and faculty at Peter Pitseolak
 High School, Cape Dorset
Toronto Arts Council
Mary Pien
David Pien
The Boate family

MCINTOSH GALLERY

Founded in 1942 at Western University, McIntosh
Gallery is a centre for the production, exhibition,
interpretation and dissemination of advanced
practices and research in the fields of art history
and contemporary art.

www.mcintoshgallery.ca

ACKNOWLEDGEMENTS

It was a great pleasure for everyone at McIntosh
Gallery to work with Ed Pien on Luminous
Shadows. We are indebted to him for his generosity
and dedication to the project, but most of all for
his profoundly moving work. McIntosh Gallery
thanks Catherine de Zegher and Angela Kingston
for their engaging essays, which complement and
expand upon the content of the exhibition. In
addition to contributing greatly to this publication,
Dave Kemp's fine photographs provide critical
documentation of the carefully considered but
ephemeral installations that comprised the exhibition.

At the gallery we are grateful to curator Catherine
Elliot Shaw for conceiving of the exhibition and
working closely with Ed to ensure the project's
success. Collections manager Brian Lambert and
preparator Brian Wellman, along with Samantha
Noseworthy, assisted the artist with what was, by
all accounts, a challenging and complex installation.
We are particularly indebted to Toronto artist
Johannes Zits, Ed's partner, for his steadfast
commitment to the realization of the exhibition.

The exhibition and publication would not have
been possible without the generous financial
support of our donors and funders. We are indebted
to those who had the foresight and generosity to
make revenue available for such worthy projects
through the Beryl Ivey McIntosh Gallery Fund,
the Tom Arnott and Arlene Kennedy McIntosh
Gallery Fund and the McIntosh Gallery Director's
Fund. We are much obliged to the Canada Council
for the Arts and the Ontario Arts Council for their
ongoing annual support of our exhibitions,
programs and publications.

James Patten
Director and Chief Curator

Contributors and Acknowledgements

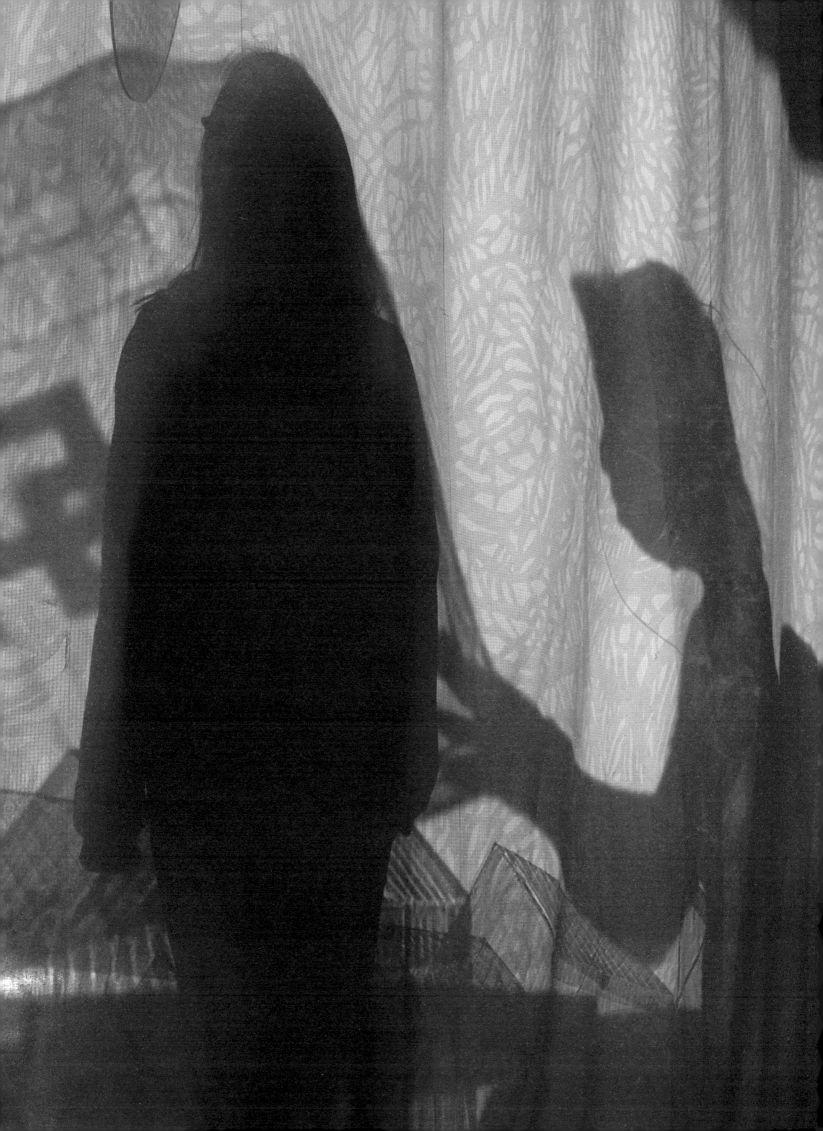

This publication explores the practice of Ed Pien and documents
the exhibition Ed Pien: Luminous Shadows curated by Catherine
Elliot Shaw and presented at McIntosh Gallery from 5 November
to 12 December, 2015.

Curator: Catherine Elliot Shaw
Essayists: Catherine de Zegher and Angela Kingston
Photography: Dave Kemp (unless indicated otherwise)

Design: Chris Lacy at Black Dog Publishing

Black Dog Publishing Limited,
10A Acton Street, London
WC1X 9NG, United Kingdom

t. +44 (0)207 713 5097
f. +44 (0)207 713 8682
info@blackdogonline.com
www.blackdogonline.com

ISBN 978-1-910433-96-6

Black Dog Publishing is an environmentally responsible company.
Ed Pien: Luminous Shadows is printed on sustainably sourced paper.

Western
McIntoshGallery

Canada Council Conseil des arts
for the Arts du Canada

ONTARIO ARTS COUNCIL
CONSEIL DES ARTS DE L'ONTARIO
an Ontario government agency
un organisme du gouvernement de l'Ontario

TORONTO
ARTS
COUNCIL

FUNDED BY
THE CITY OF
TORONTO

art design fashion
history photography
theory and things

black dog
publishing

www.blackdogonline.com london uk